Remembering
Washington
State

Dale E. Soden

TURNER
PUBLISHING COMPANY

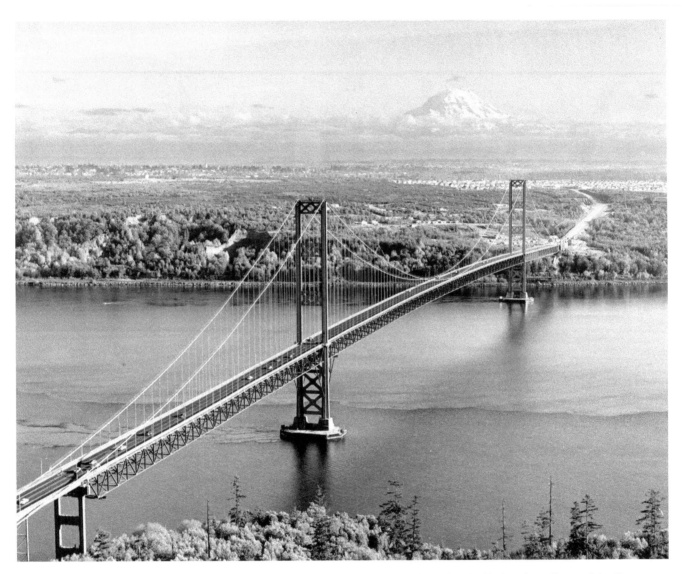

Shown here in 1950, the Second Tacoma Narrows Bridge eliminated the design flaws that had led to the collapse of the first. Opening on October 14, 1950, the bridge was nicknamed "Sturdy Gurtie" by local residents and is now accompanied by another bridge, which opened in July 2007. These two bridges are currently the fifth-longest suspension bridges in the world.

Remembering Washington State

Turner Publishing Company
4507 Charlotte Avenue • Suite 100
Nashville, Tennessee 37209
(615) 255-2665

Remembering Washington State

www.turnerpublishing.com

Library of Congress Control Number: 2010924328

ISBN: 978-1-59652-674-7
ISBN-13: 978-1-68336-904-2 (pbk)

Printed in the United States of America

CONTENTS

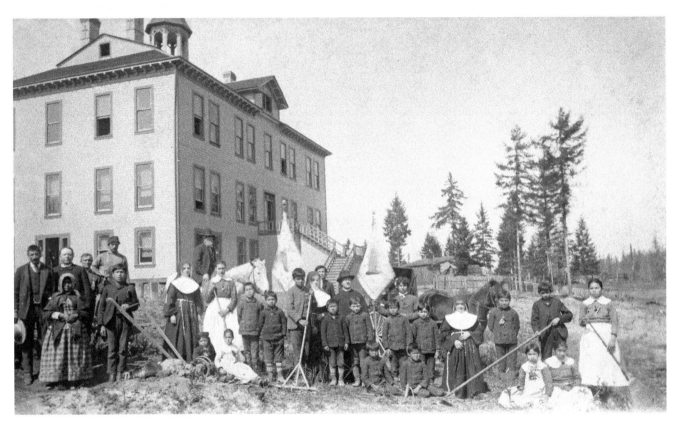

St. George's Industrial School located 1.5 miles from Milton, Washington, near present-day Puyallup. In 1888, the Reverend Peter Hylebos along with the Sisters of St. Francis established a Catholic mission school for Puyallup Indian boys and girls. The school was part of a larger effort to assimilate Native Americans into Western culture by teaching them "industrial arts" as well as agriculture, domestic science, and Christianity.

Acknowledgments

This volume, *Remembering Washington State,* is the result of the cooperation and efforts of many individuals and organizations. It is with great thanks that we acknowledge the valuable contribution of the following for their generous support:

Library of Congress
Washington State Historical Society

PREFACE

Every state has its own story. Telling that story in a clear and comprehensive way is a challenging task for any historian. Individual events as well as more complex cultural attitudes and expressions are often the result of a number of forces intertwined with one another over the span of many years. The history of Washington State is no exception. Blessed with a geographical splendor that few states in the lower 48 can match, Washington has been home to both Coastal and Plateau Indians for centuries. Originally part of the Oregon Territory, Washington did not become a state until 1889. Over the past 150 years, the rich history of the state was shaped by the coming of the railroads, abundant agriculture, the Grand Coulee Dam, and innumerable entrepreneurs, and less favorably, by labor and ethnic disputes and economic depression. More recently, Boeing, Microsoft, and Starbucks have all contributed to the state's reputation as one of the most significant economic and cultural centers of the nation.

This photographic history attempts to present part of that complicated story through the lenses of many photographers. More than 100 images shown here present a remarkable picture of several aspects of this story. Within this collection are many images of two of Washington's most famous photographers, brothers Edward and Asahel Curtis. Both had a keen eye for composition. Edward was particularly interested in Native American life and the coming of the railroads. Asahel was interested in Seattle, the Alaskan Gold Rush, and Mount Rainier. Another photographer featured in this collection is Marvin Boland. Trained as a commercial photographer, Boland came to Tacoma in 1915 and documented everything from movie stars and mill workers to shipyard workers and waitresses. He served as the official photographer for Camp Lewis during World War I.

The strength of this collection of photographs is in its depiction of the lives of common people, particularly in the early twentieth century. These photographs reveal Washington as it evolved from a land primarily populated by Native Americans to one where agricultural enterprises dominated small towns and rural communities. The photographs also reveal the tremendous impact of the coming of the railroad as well as the importance of timber, fishing, and agriculture to the state. One can sense how hard the physical labor was, how isolated many of the communities were, and how challenging life was for most people.

The photographs in this book are grouped in five chronological eras. The first section covers the period from 1860 to 1899. Conflict with Native Americans is documented along with the coming of the railroads, statehood, and the state's connection to the Alaskan Gold Rush. The second section spans the period from 1900 to 1909 and focuses on the emergence of the timber industry as well as growing urbanization in the state. Increasing confidence in technology is also evident in several photographs. The third section focuses on the period from 1910 to 1919. The timber industry continued to play an important role as well as coal mining in western Washington. Tourism grew more popular, and World War I exacerbated tensions between labor and management, culminating with the Seattle General Strike in 1919.

The fourth section concentrates on the period between the wars from the 1920s through the 1930s. Increasingly, the Pacific Northwest became connected to the rest of the country through popular culture. Movie stars and sports heroes visited the region, and the automobile made more accessible the beauty of Mount Rainier and Olympic National Park. The Great Depression of the 1930s challenged residents economically as well as psychologically, but the state was also awarded some of the grandest public works projects in the nation, most notably, the Grand Coulee Dam.

The final section touches on the period from the 1940s through the 1950s. Washington was significantly affected by World War II. From the nearly 6,000 Washington State residents who gave their lives in the war to the development of Hanford as a place where plutonium was produced for the atomic bomb, Washington was a wartime epicenter. After the war, suburbs sprouted up with the aid of new highways and bridges like the Tacoma Narrows, and the relentless search for hydroelectric power resulted in the construction of more dams on the Columbia River.

With the exception of touching up imperfections that have accrued with the passage of time and cropping where necessary, no changes have been made. The focus and clarity of many images are limited to the technology and the ability of the photographer at the time they were recorded.

This collection of photographs provides an opportunity to ponder the rich history of a state that has emerged from the hinterland into one that increasingly influences the broader culture of the United States. As the home of Boeing and Microsoft as well as Starbucks and the Space Needle, the State of Washington is known throughout the world for its entrepreneurial character and natural beauty. The root of that identity is revealed in the photographs that follow.

—Dale E. Soden

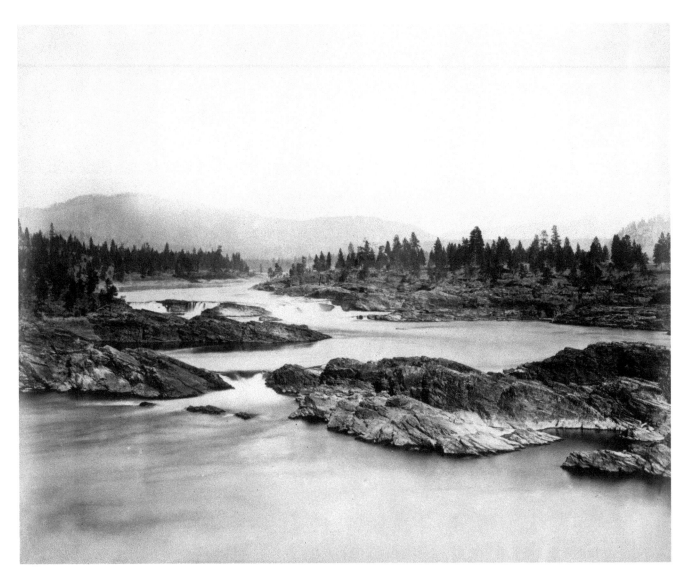

Washington's great river—the Columbia—at Kettle Falls in northeastern Washington near the Canadian border in 1860. Native Americans gathered for centuries to fish at the falls.

An Emerging State

(1860–1899)

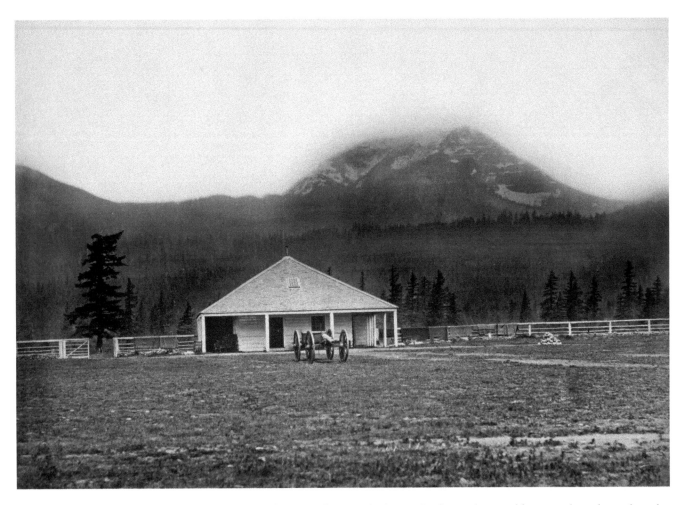

The U.S. military exerted an important presence. This post, photographed in 1860, featured a guard house and was located on the Columbia River in the lower Cascade Range.

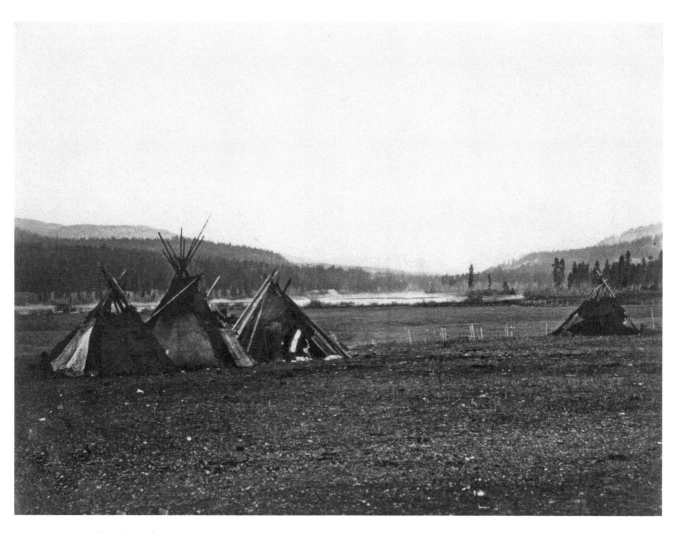

The clash of cultures is evident in this 1860 photograph of Indian tepees located near Fort Colville in what became northeastern Washington.

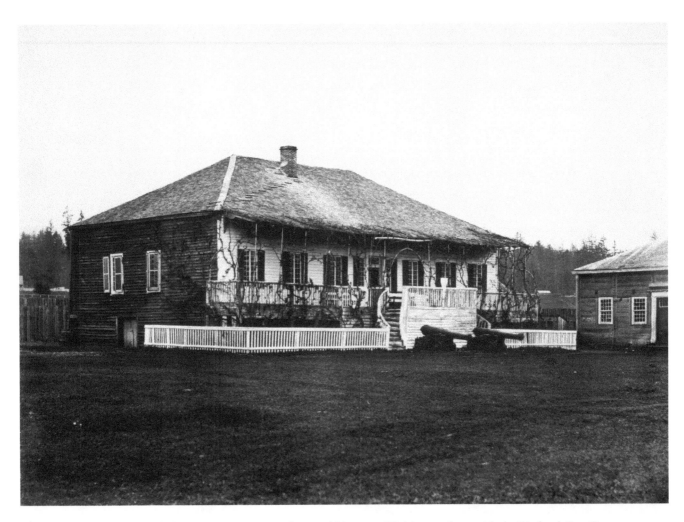

In 1825, the British established a strong presence in what would become Washington State with the Hudson's Bay Company, near present-day Vancouver, Washington. This photograph features the officers' mess hall. The Company, led by John McLoughlin, made considerable profit in the fur-trading business for the next 20 years.

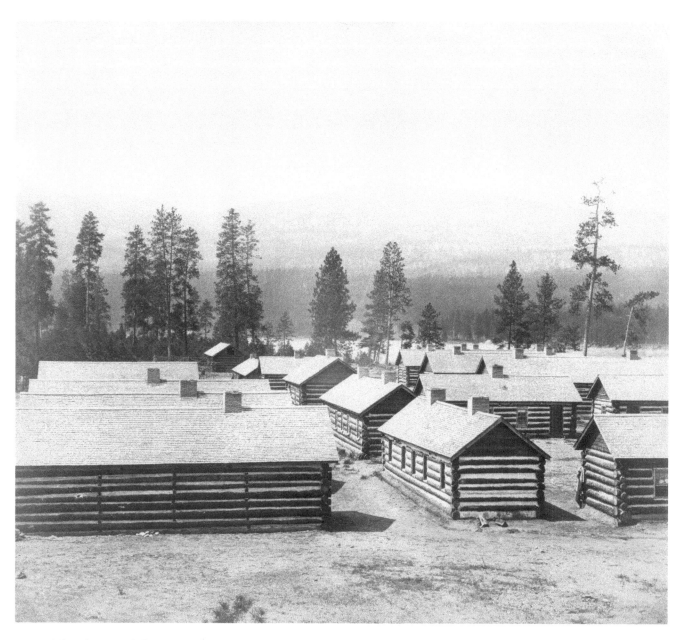

This photograph features 15 or more log cabins of the British North American Boundary Commission two miles above the Hudson Bay Company's post at Colville near Kettle Falls.

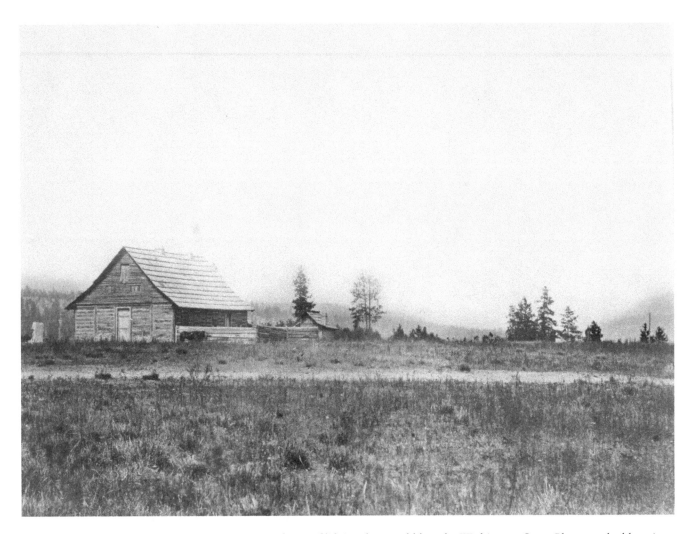

Catholic and Protestant missionaries were an integral part of life in what would later be Washington State. Photographed here in 1860 is the Roman Catholic St. Paul's mission near Fort Colville originally built in 1847 to serve the estimated 800 Indians who gathered annually to fish at Kettle Falls.

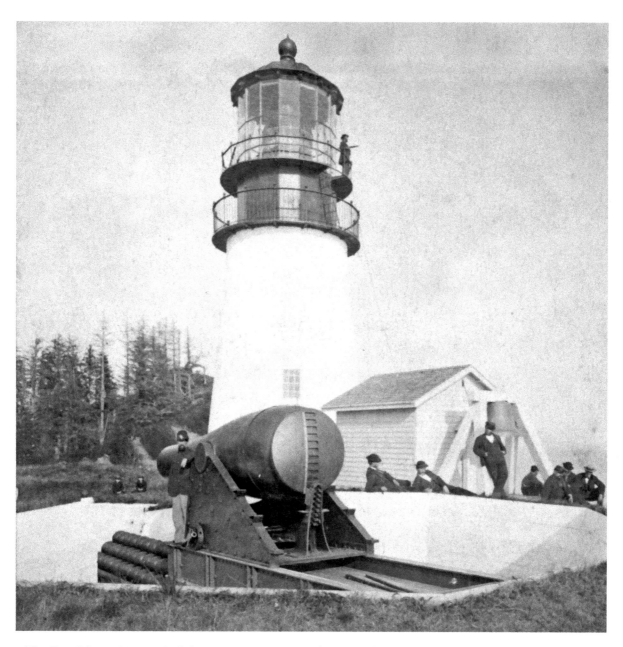

The Cape Disappointment Lighthouse warns mariners as they enter the treacherous mouth of the Columbia River, discovered by American Robert Gray in 1792. First lit on October 15, 1856, the lighthouse stands 53 feet tall with a focal plane 220 feet above sea level.

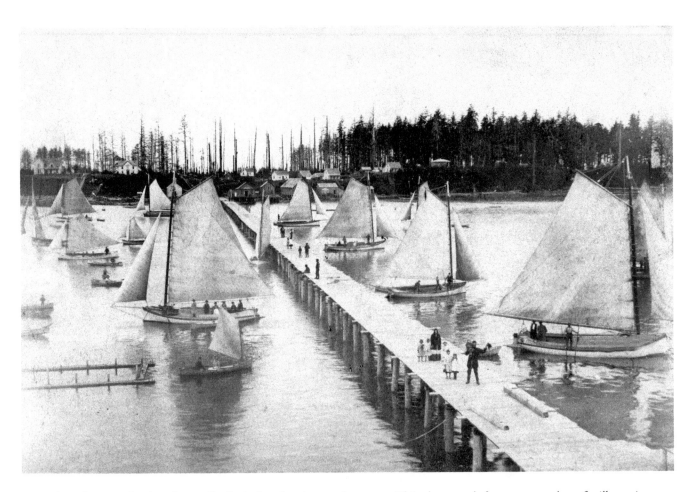

Coastal Washington developed sporadically during the nineteenth century. This photograph features a number of sailboats in Shoalwater Bay in 1884 near Willapa Bay on the southern Washington Coast. Shoalwater Bay had been the wintering place of both the Chinook and Lower Chehalis Indians.

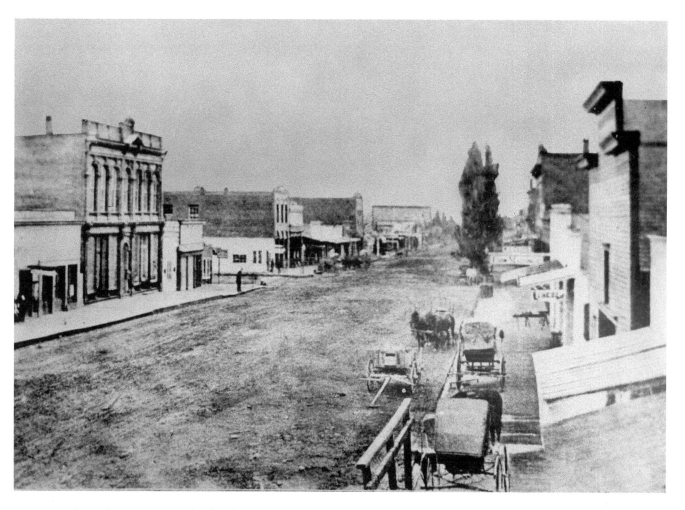

By 1860, one in six settlers lived east of the Cascades, and in a short time, Walla Walla emerged as the first town of any significance in the Washington Territory. Featuring the first commercial bank as well as the first college (Whitman), the community has supported the oldest continuing symphony west of the Mississippi River.

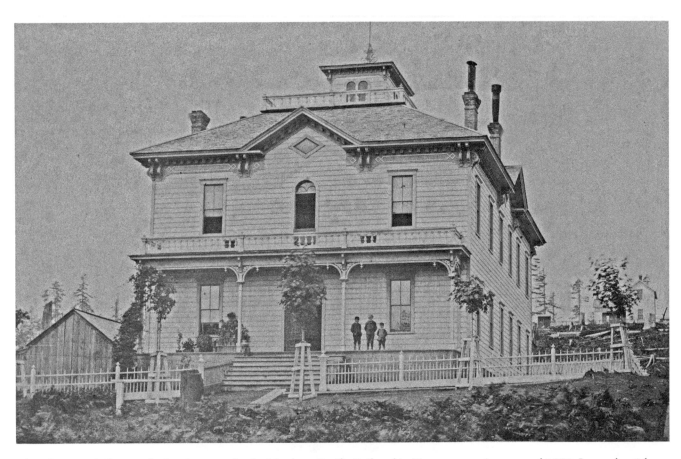

This photograph features the headquarters for the Northern Pacific Railroad in Tacoma sometime around 1880. Located at 9th and C streets, the building later became the Sylvan Hotel. The Northern Pacific announced Tacoma as its West Coast terminus in 1873 and the first trains arrived in 1874.

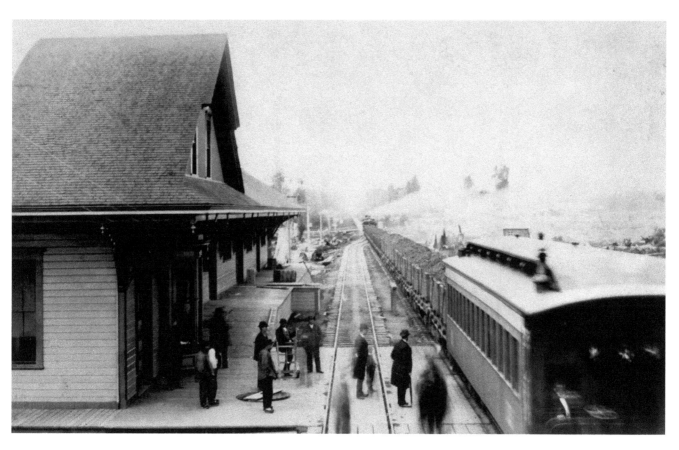

This is a photograph in 1883 of the Northern Pacific train depot in Puyallup, 10 miles east of Tacoma. The Northern Pacific established a stop in Puyallup as early as 1877.

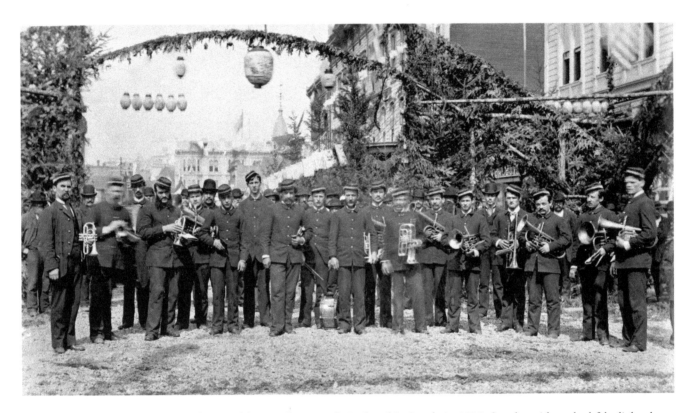

This brass band played at the completion of the Northern Pacific Railroad in Seattle in 1883. Seattle residents had felt slighted ten years earlier when Tacoma was selected for the terminus, but the Depression of 1873 stunted Tacoma's early growth, allowing Seattle to continue to evolve as a port city and eventually a railroad terminus.

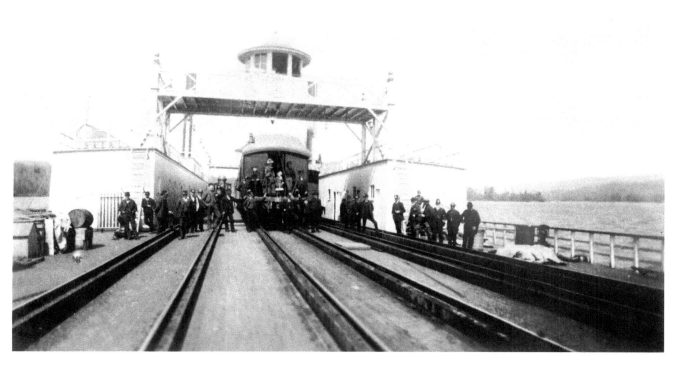

The connection between railroad and steam ferry transportation is illustrated in this 1885 photograph of the ferry *Tacoma* at the Kalama port in southern Washington. This ferry line transported trains from Kalama to Goble, Oregon, from 1884 until 1908, when a railroad bridge was constructed.

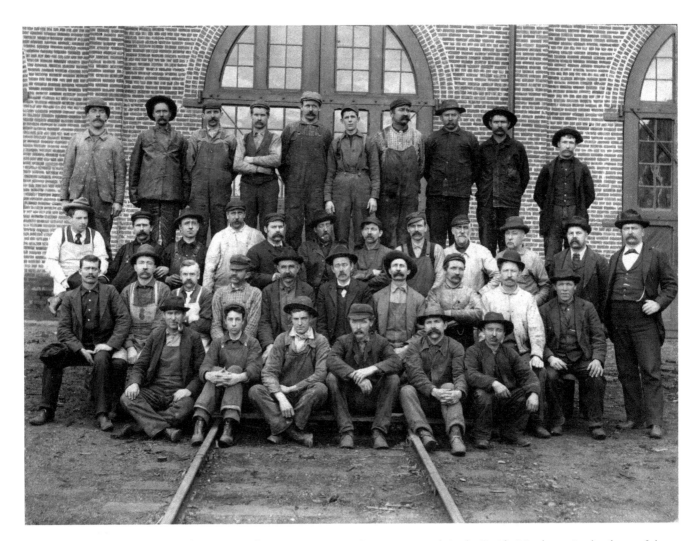

Men from throughout the United States as well as European countries came to work in the Pacific Northwest in the shops of the Northern Pacific Railroad. Featured here are men in the South Tacoma shops. Opening in 1891, the shops reportedly became the largest in the West. Rail cars were both repaired and built there.

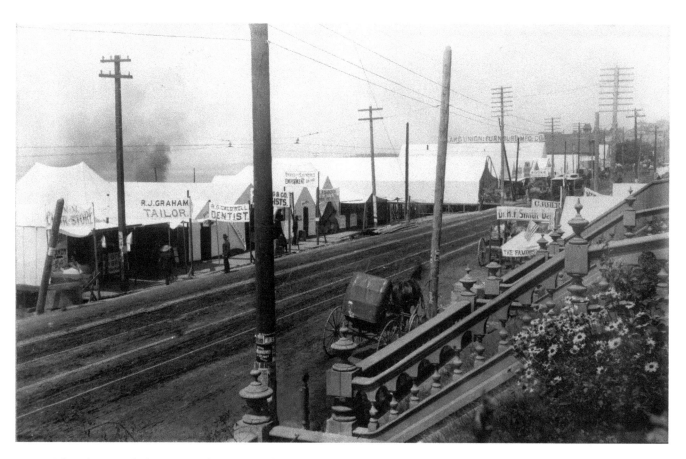

This photograph shows Second Avenue and Marion Street in Seattle, Washington, in July 1889. Twenty-nine city blocks of downtown Seattle had burned to the ground on June 6, 1889. Consequently, the city's businesses operated out of tents over the next several years until new brick buildings could be constructed.

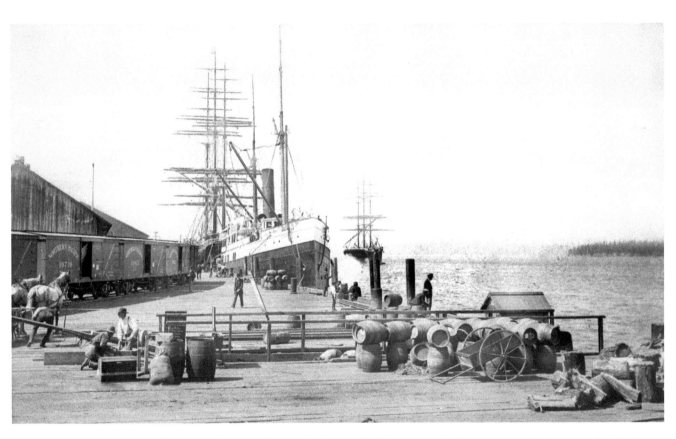

The Northern Pacific Railroad wharf in Tacoma, photographed around 1890, reflects the importance of trade across the Pacific Ocean to Asia in the late nineteenth century.

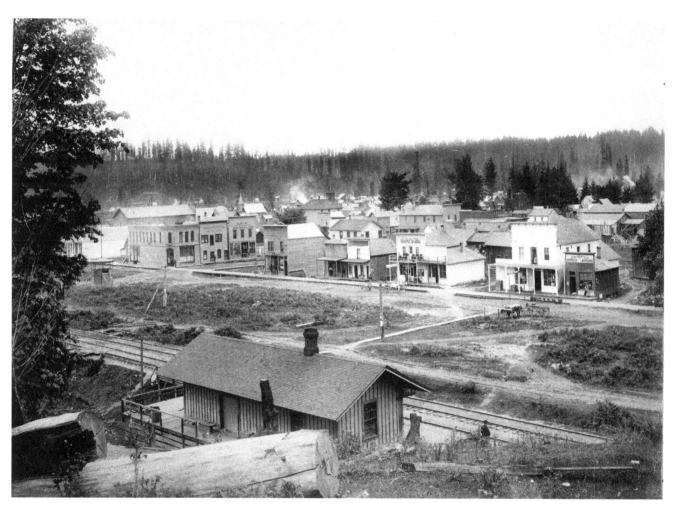

Front Street in Castle Rock, Washington, reflects the emerging commerce of Washington State before the turn of the century. Access to the railroad was crucial for these small communities.

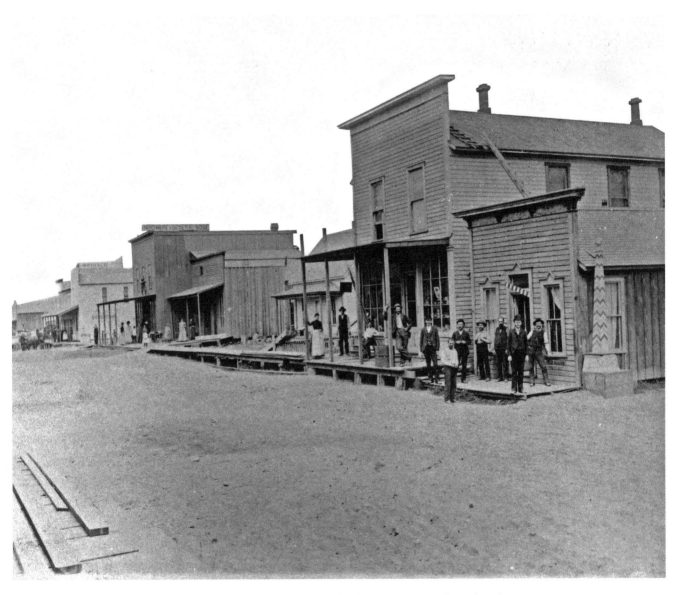

Castle Rock, incorporated in 1890, eventually became known as the "Gateway to Mt. St. Helens."

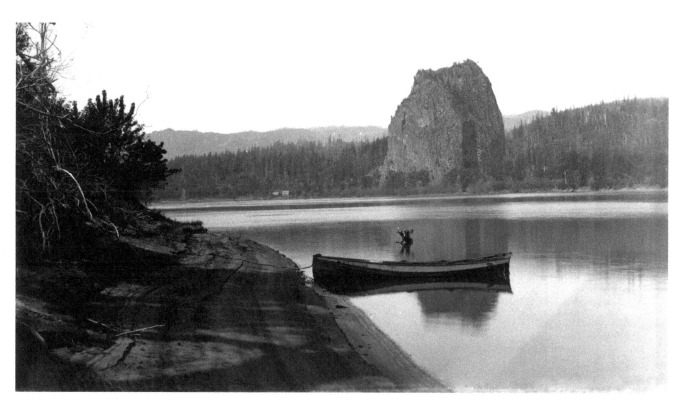

Beacon Rock, once known as Castle Rock, is located 36 miles east of Vancouver, Washington, on the Columbia River. Consisting of conical columnar lava, it points to Washington's prehistoric geology.

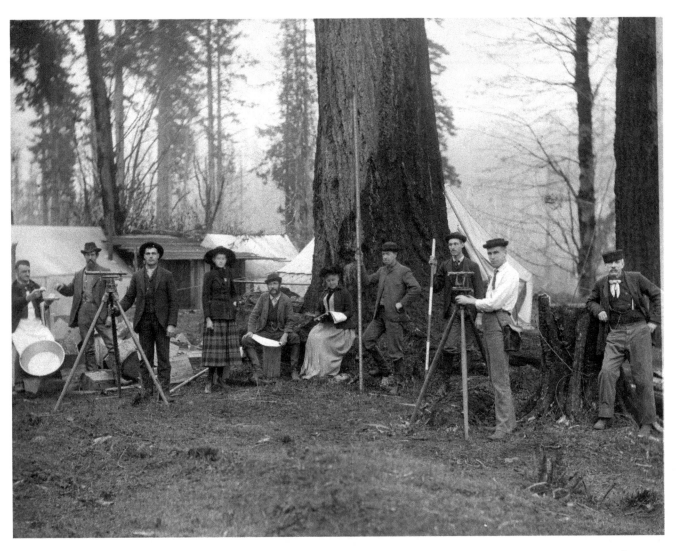

Surveying for railroads proved to be crucial to the economic development of the state. Encamped here in 1890, surveyors for the Tacoma, Olympia, and Grays Harbor Railroad, later incorporated into the Northern Pacific, pose for the photographer. The camp was apparently destroyed on Christmas morning 1890, by a windstorm.

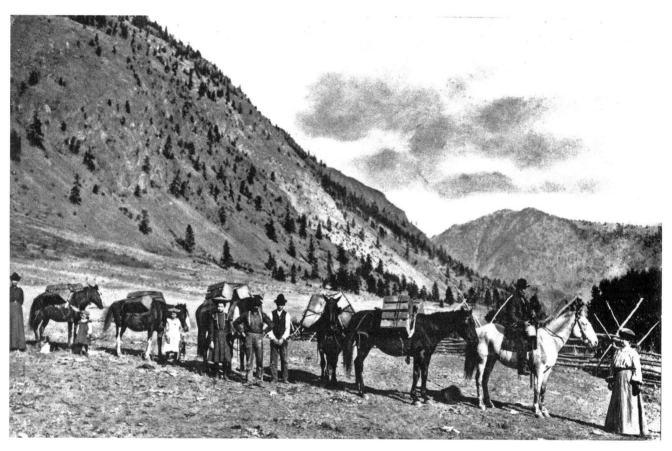

Mining provided an important source of income for Washington residents during the late nineteenth and early twentieth centuries. Photographed here are men, women, and children, outfitted with supplies near Loomis, Washington, in the north-central part of the state. Early settlers of Loomis were cattle ranchers and farmers as well as miners.

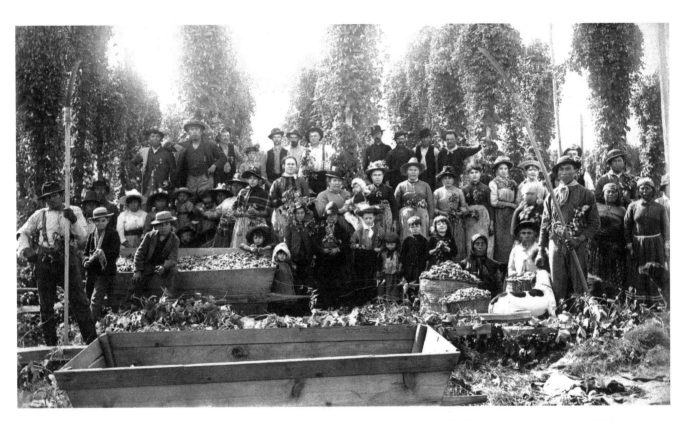

Photographed in the 1890s, these hop pickers reflect the importance of this crop in early Washington State history. This particular image features people in Slaughter, Washington, a small community near present-day Auburn.

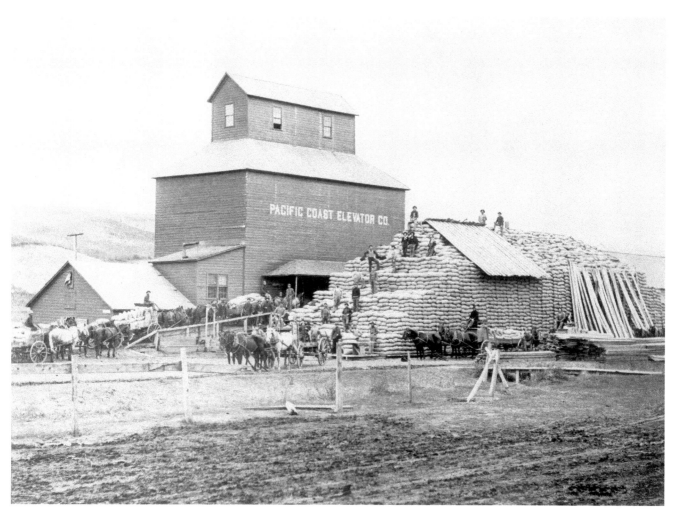

Grain elevators became a familiar sight throughout the state in the 1890s. Pictured here is the Pacific Coast Elevator Company in Thornton, Washington, south of Spokane in Whitman County. Horse-drawn wagons remained a crucial form of transportation in the Palouse country of eastern Washington.

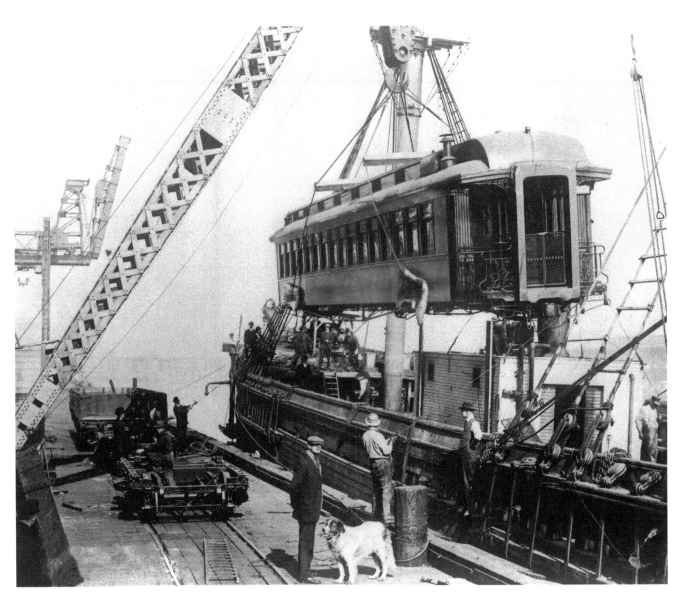

Seattle became an important station for those embarking to join the Alaskan Gold Rush of 1897. Photographed here is a railroad car on a Seattle dock, being loaded for transport to Alaska.

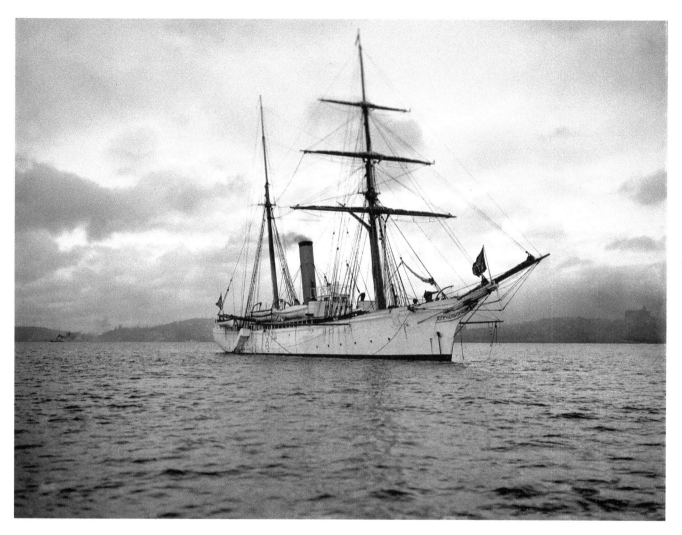

Built in Port Blakely in 1885 for the purpose of cruising in Alaskan ice fields, the Coast Guard Cutter *Rush* remained in service for many years. It is shown here in 1901 in an image by one of the Pacific Northwest's best-known photographers, Asahel Curtis, who took a particular interest in the Klondike Gold Rush.

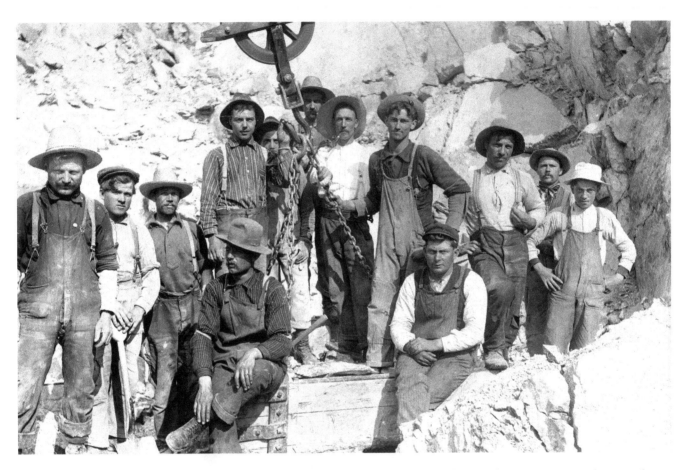

At the turn of the century, the availability of work in the various rock quarries around the state drew immigrants, who came from all parts of the world.

Optimism Abounds

(1900–1909)

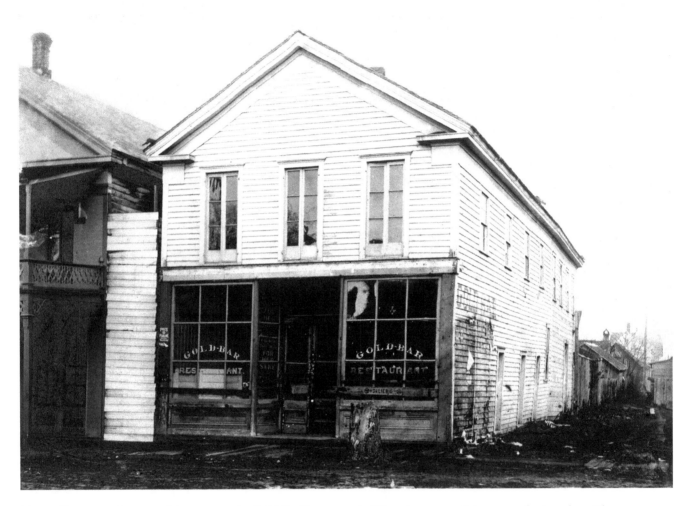

Pictured here near the turn of the century, the Gold Bar Restaurant in Olympia was a well-known gathering place. The Washington Territorial Legislature met there in the 1850s prior to statehood.

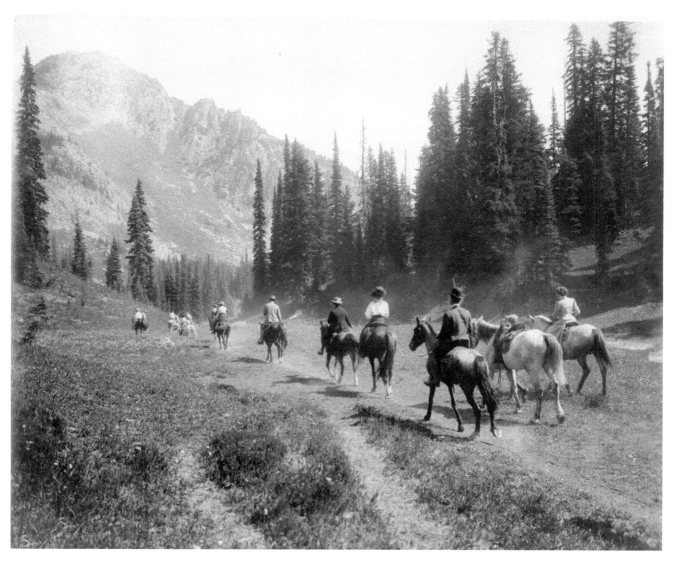
Horseback riders frequently made the trek up the trail of Indian Henry's in Mount Rainier National Park. Tourism began to emerge as an important element of the economy in the late nineteenth and early twentieth centuries.

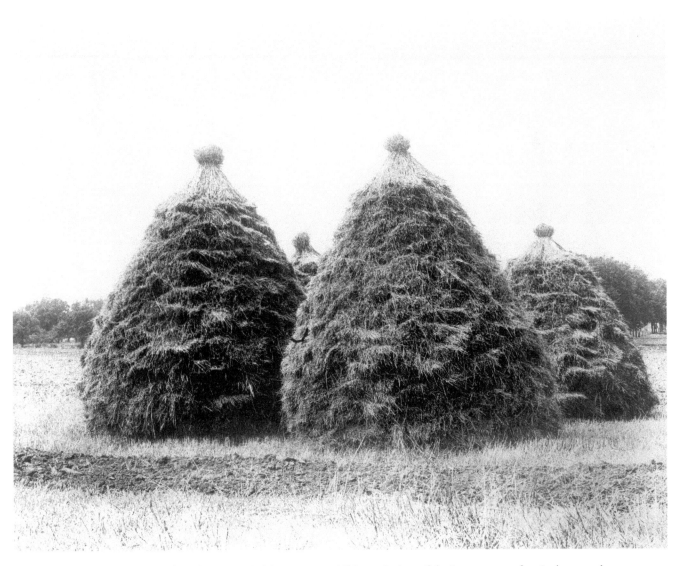

The many haystacks that once dotted eastern Washington were visible reminders of the importance of agriculture to the state's economy.

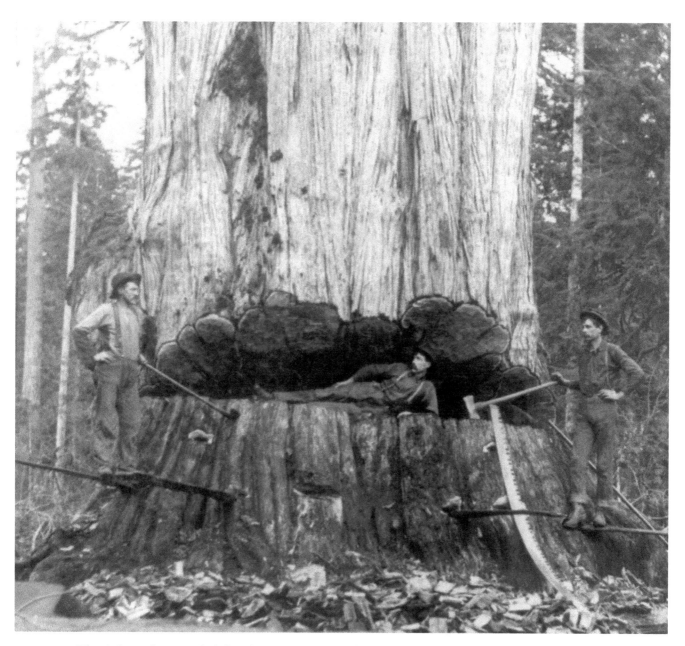

The timber industry exploded in the western part of the state particularly under the entrepreneurial effort of Frederick Weyerhaeuser. The extensive logging of old growth forests would later result in controversy, but in 1902, when this photograph was taken, spectacular images of lumbermen wielding axes and crosscut saws abounded.

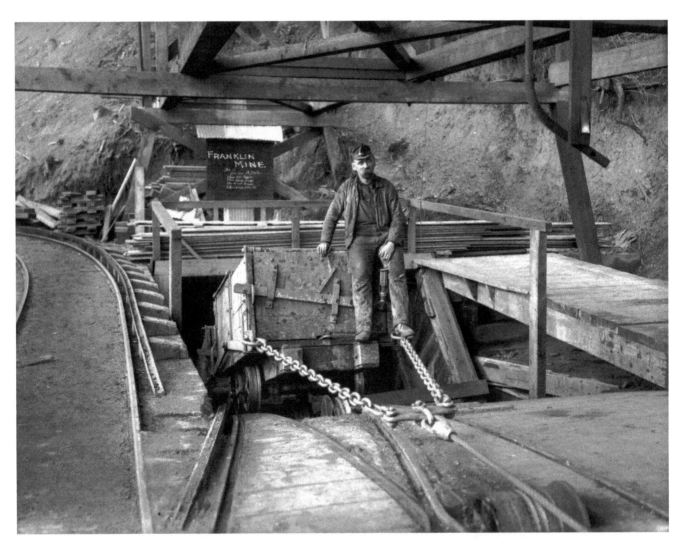

A coal miner emerges on a coal car at the Franklin mine in King County in 1902. On August 27, 1894, 37 men were killed while fighting a fire in the Franklin mine. Apparently the fire was deliberately set, and the miners were trapped 1,300 feet below ground.

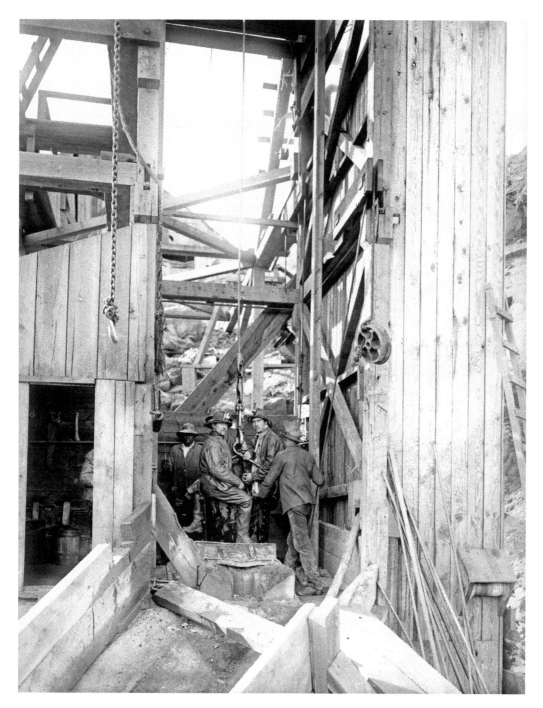

Several miners wait to be lowered into the Franklin mine at the entrance to the shaft. In the 1894 fire, 37 miners lost their lives.

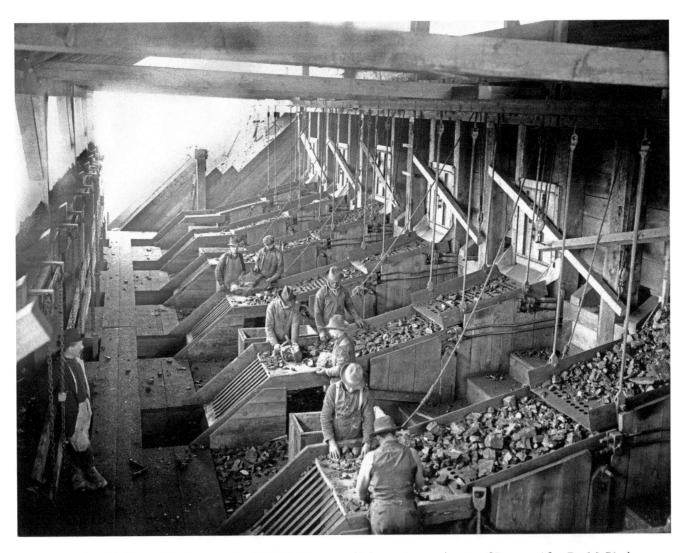

Men sort coal in this Newcastle mine near Franklin, Washington, which now is near the city of Renton. After Dr. M. Bigelow discovered a bed of coal in 1853, coal mining quickly emerged as an important enterprise east of Lake Washington.

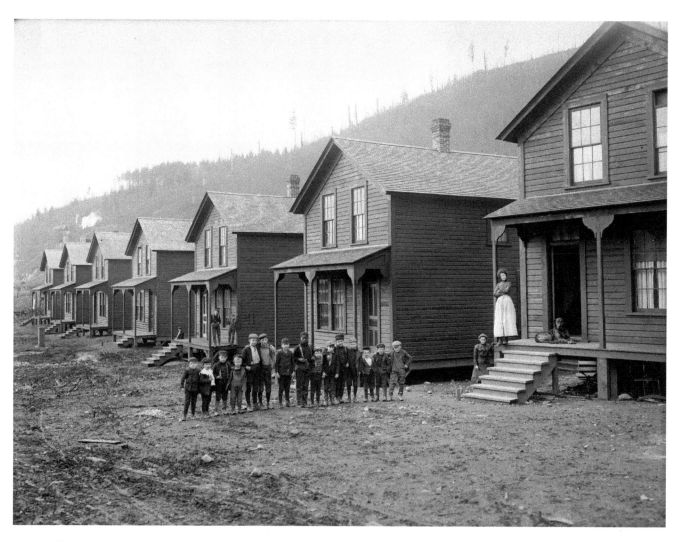

Franklin mine owners constructed company housing for the workers. Pictured here in 1902 are 15 boys of different ages. Child labor was common at the turn of the century.

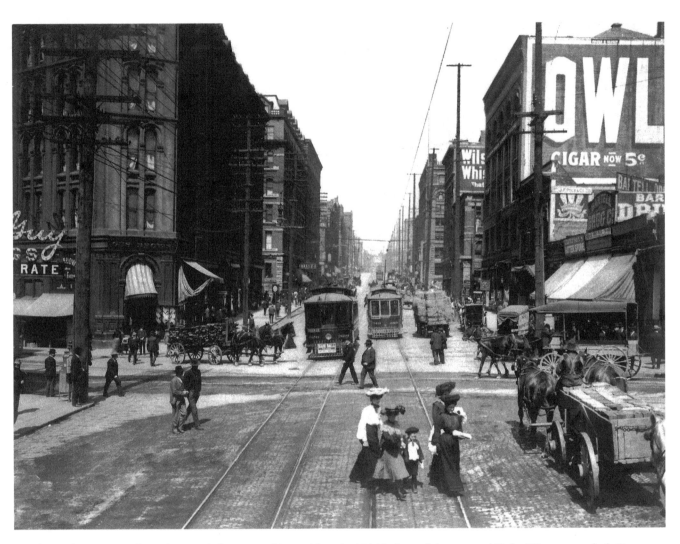

Seattle was booming in the early twentieth century. Pictured here in 1904 is Second Avenue and Yesler Way, near today's Pioneer Square. The population of the city grew from 80,871 in 1900 to 237,174 in 1910.

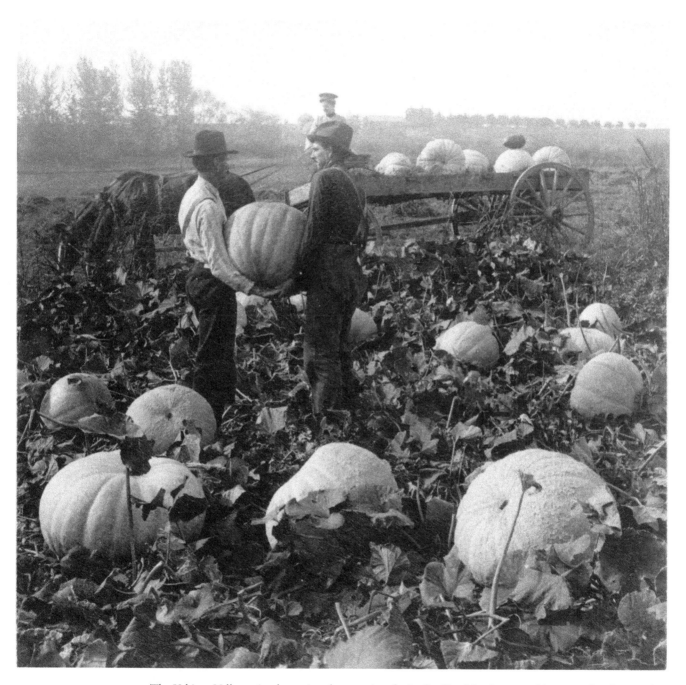

The Yakima Valley gained a national reputation for its fertility. Massive pumpkins proved to be popular.

Featured here is what was known as the "McKinley Stump" in Chehalis, Washington. From that stump, presidents McKinley, Taft, and Roosevelt spoke to crowds, official visits that reflected the growing importance of Washington politically.

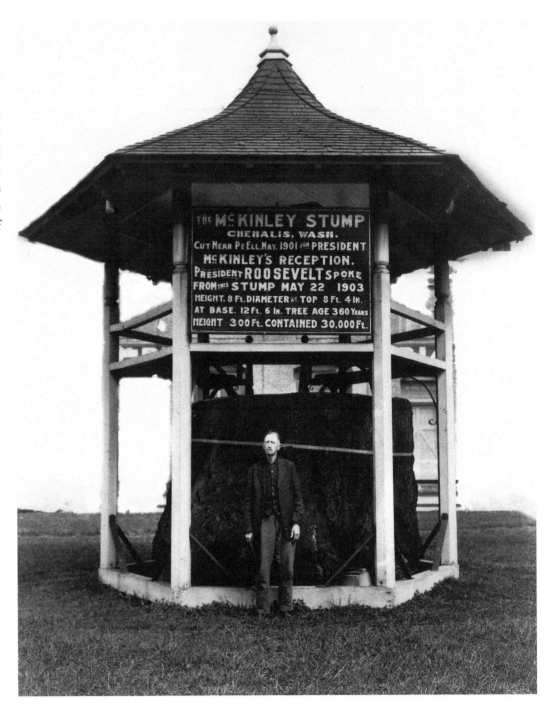

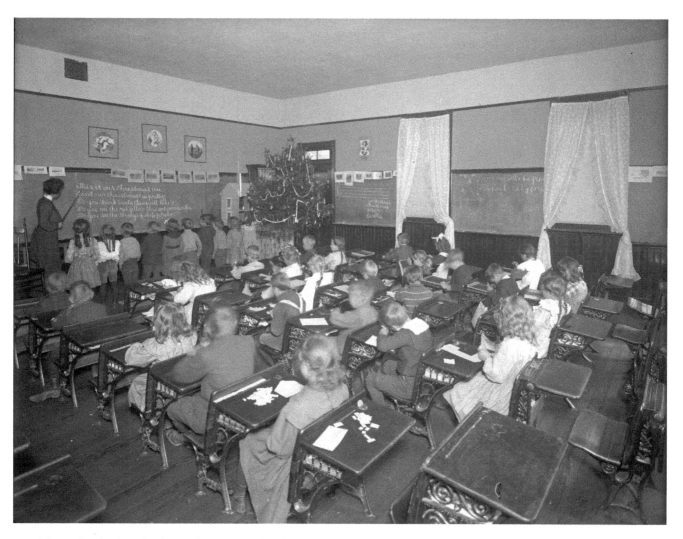

This is the third-grade class at the Latona School in Seattle in 1905. Apart from the Christmas tree in the corner, the teacher's emphasis on cursive writing reminds one of what changes have taken place in instruction since that time.

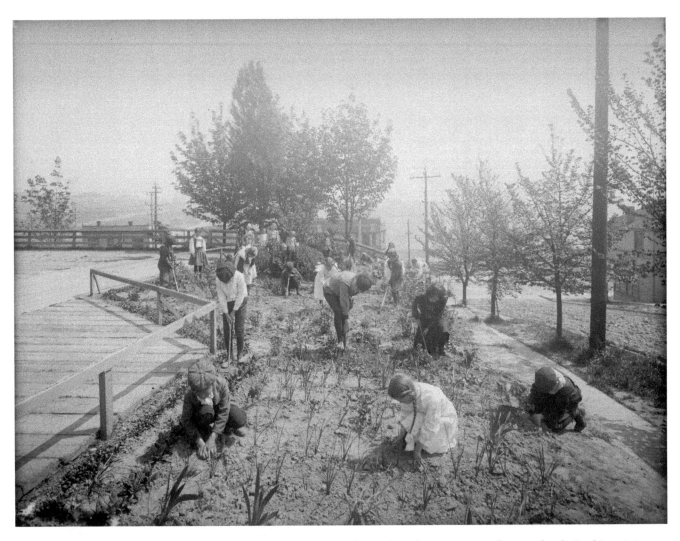

Children throughout the state spent parts of many days working in the gardens that accompanied most schools. In this 1905 photo of the South School in Seattle, located on Weller between 10th and 12th Avenue South, children are tending plants.

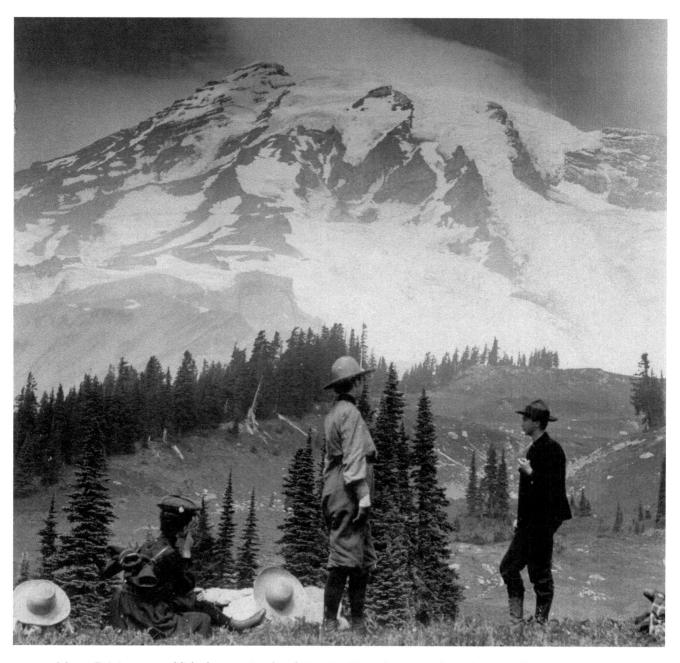

Mount Rainier was established as a national park in 1899. From the outset, the park attracted both men and women to its spectacular views.

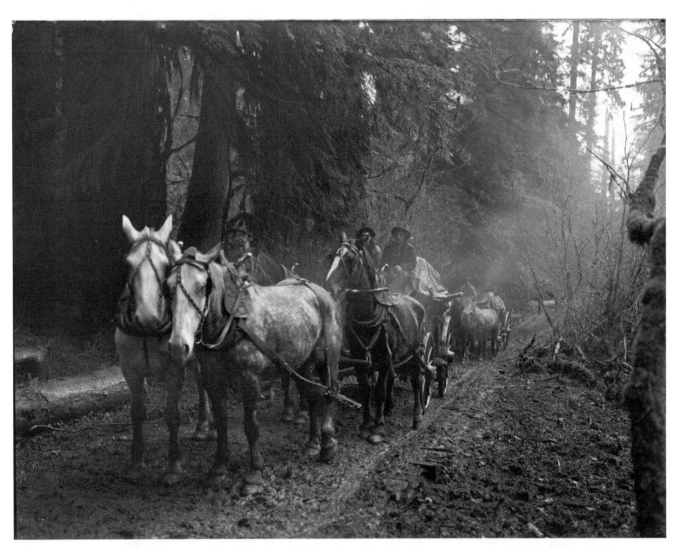

Constructing railroads in the Cascade Mountains depended heavily on horse-drawn transportation. This photograph taken near Snoqualmie Pass in 1906 conveys something of the struggle to forge railroad tracks through the mountains.

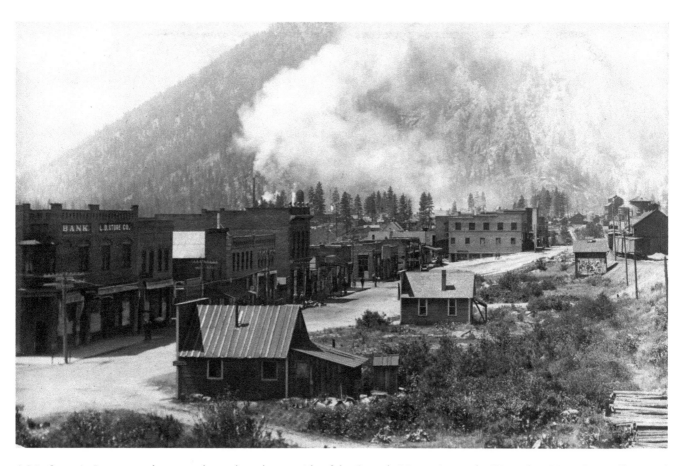

Main Street in Leavenworth, a town located on the east side of the Cascade Mountains on the Wenatchee River. Originally named "Icicle" in 1891, Leavenworth has become famous as a tourist destination for adopting a Bavarian motif.

Chinese immigrant workers were essential to the construction of railroads throughout the West and were frequently photographed doing some form of manual labor. Anti-Chinese riots marked the Northwest in the 1880s, but some individuals, such as Chin Gee-Hee, photographed here in the early twentieth century, rose into management. Gee-Hee became a contractor for the Seattle, Lake Shore, and Eastern Railroad Transportation Company.

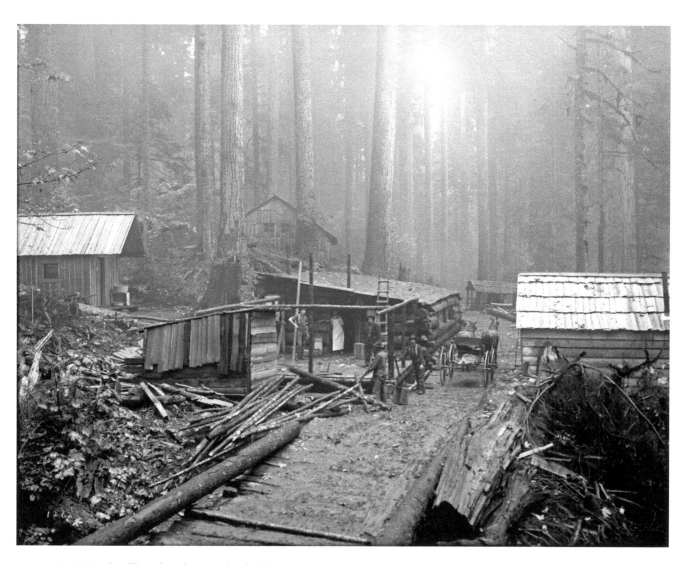

R. H. Barkwell's Milwaukee Road railroad construction camp near Snoqualmie Pass in 1906. Clearly, these railroad camps were challenging environments for the young men who hoped to scratch out a living by forging railroad lines through the Cascade Mountains.

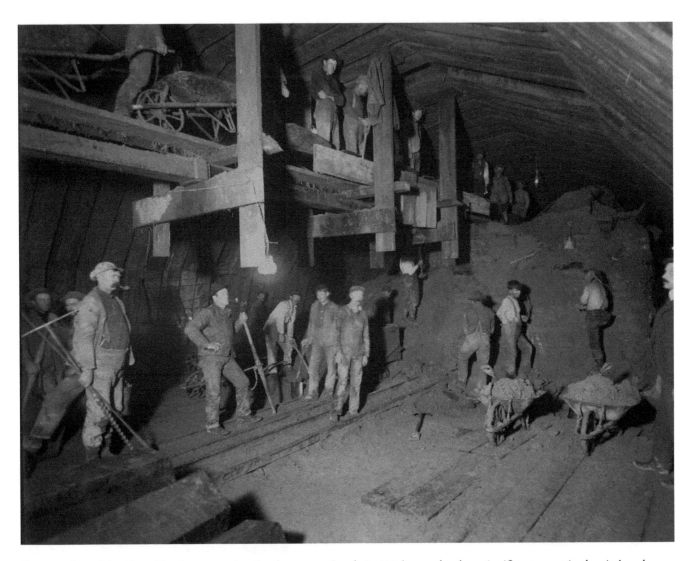

Construction of the Great Northern tunnel under downtown Seattle in 1904 proved to be a significant event in the city's early history. Still in use today, the tunnel is one mile long and runs from Alaskan Way (below Virginia Street) on the waterfront, to 4th Avenue S and Washington Street. At one time the tunnel was the largest in the nation, costing $1,500,000 to build, a debt burden shared by both the Great Northern and the Northern Pacific railroads.

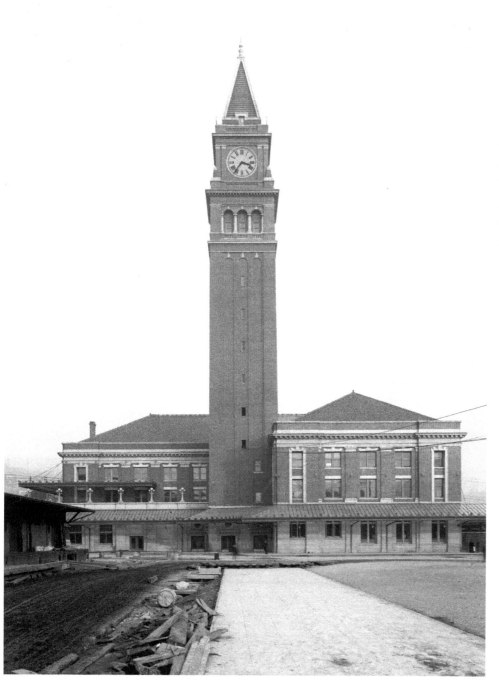

The King Street Station in downtown Seattle became one of the great early landmarks for the city. The station served both the Great Northern and the Northern Pacific railways. The tower itself is 242 feet tall and designed after the Campanile di San Marco in Venice, Italy. When completed in 1906, the building was the tallest in Seattle and contained four mechanical clock faces.

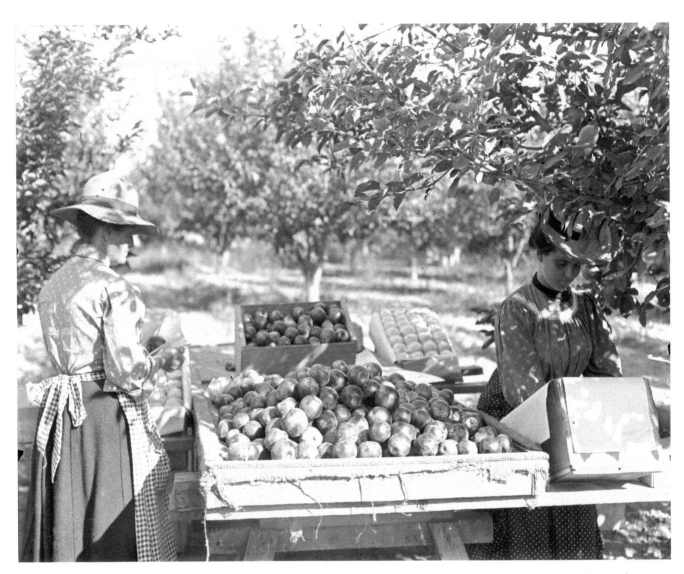

Apples proved to be an important crop in the early history of the state. Pictured here are two women in an orchard at work packing apples, probably in central Washington.

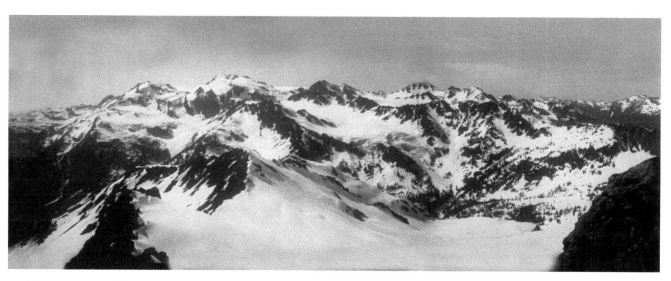

This panorama of the Olympic Mountains reminds one not only of their spectacular beauty but also of their importance to the existence of the great rain forests of the Olympic peninsula.

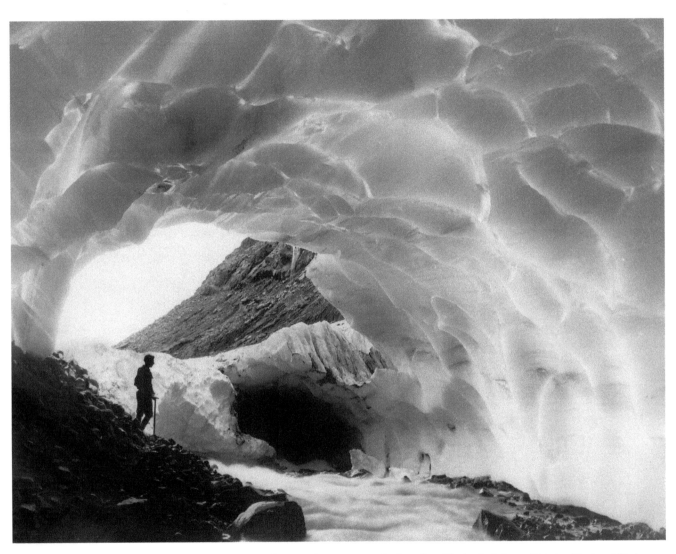

This photograph, from the early twentieth century, features the ice cavern in Paradise Glacier in Mount Rainier National Park.

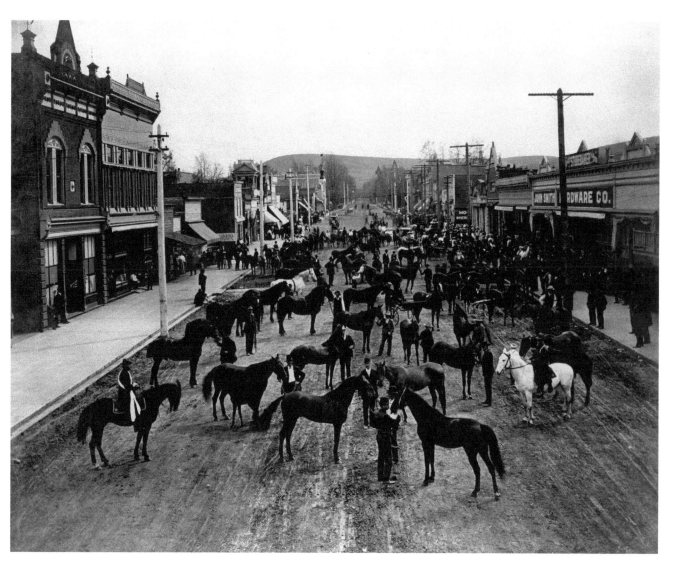

Small towns across Washington, such as Waitsburg near Walla Walla, celebrated the importance of the horse well into the twentieth century. This particular show was held on April 13, 1907. Waitsburg itself was founded in 1881.

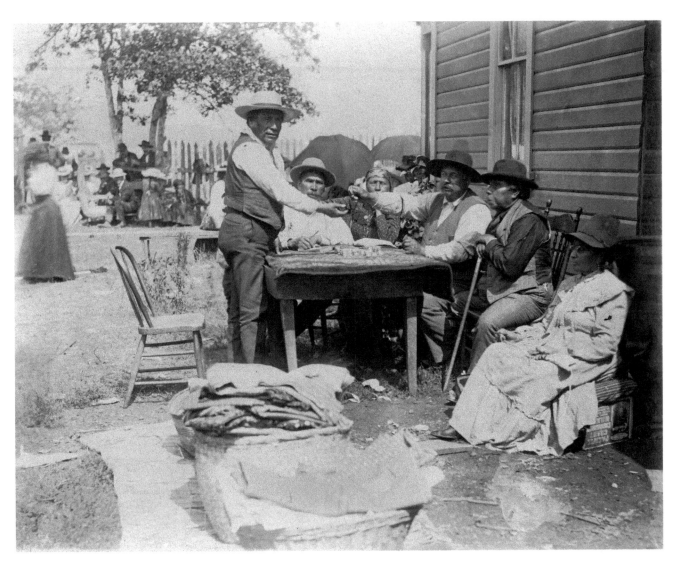

This 1907 photograph features a Nisqually-Puyallup Indian potlatch. The potlatch was a ceremony practiced for centuries that generally centered on births, rites of passages, funerals, weddings, and other noteworthy occasions. Exchange of gifts generally marked the potlatch.

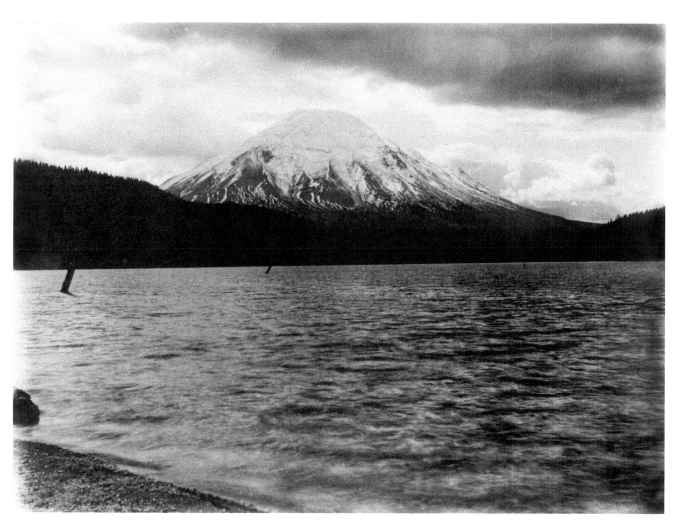

Beautiful Mount St. Helens and Spirit Lake as they appeared in the early twentieth century. On May 18, 1980, the active volcano erupted, killing 57 people. The eruption was determined to be the largest in the history of the lower 48 states in North America.

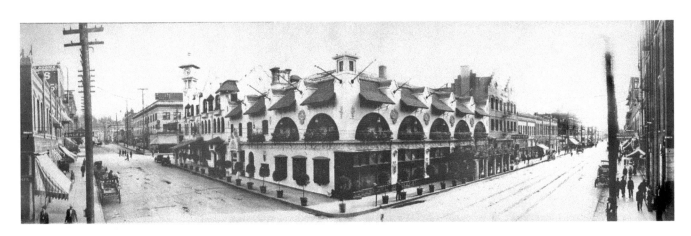

The Davenport Restaurant in Spokane, Washington, in 1908 became a leading tourist attraction, particularly after the adjoining Davenport Hotel was constructed in 1914. Both the restaurant and the hotel were designed by the most famous Spokane architect, Kirtland Cutter. Several presidents as well as Charles Lindbergh and Babe Ruth dined at the Davenport.

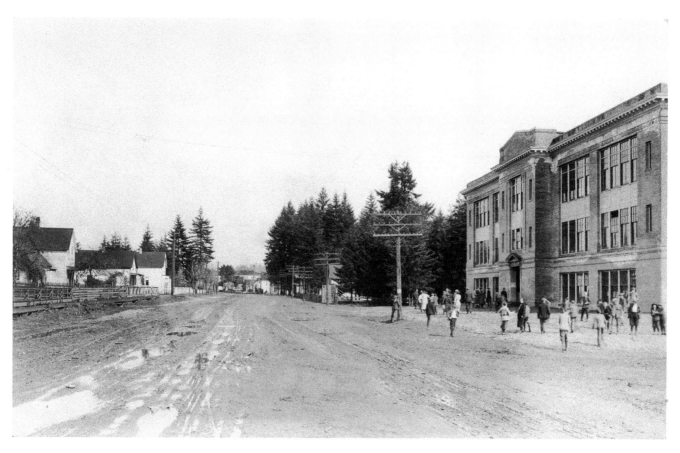

Small towns took shape throughout Washington in the early twentieth century. This broad street in Elma, Washington, located some 30 miles west of Olympia, suggests the confidence that more growth would occur. The high school, at right, indicates the importance attached to public education. The construction of the rail line through town further established Elma as the commercial service center in eastern Grays Harbor County.

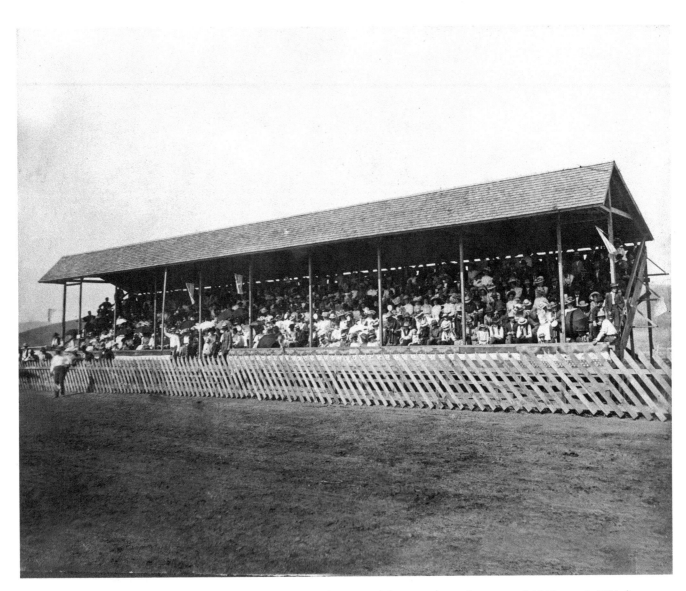

Many small communities built racetracks in the early twentieth century. This one, shown here around 1908, was in Waitsburg, Washington, near Walla Walla. The event could be a horse show, in all likelihood a more acceptable outing for both men and women of the day, as opposed to horse racing itself.

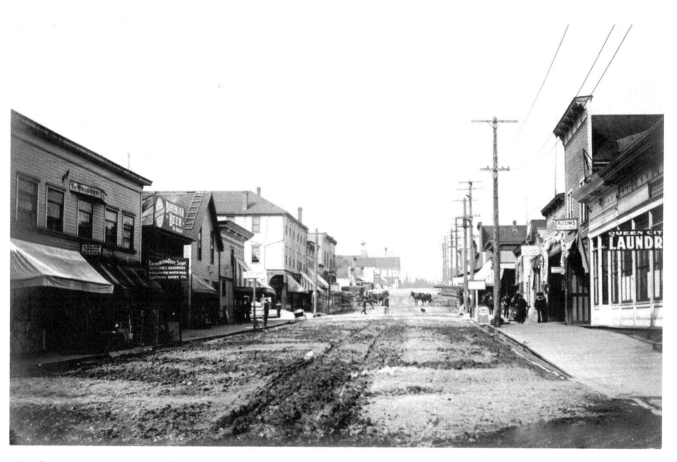

Pacific Avenue in Bremerton, Washington, in the early twentieth century. In this view, Bremerton looks more like a frontier town than the growing port facility on Puget Sound that it was. The importance of horse-drawn transportation and the challenge of unpaved streets are conspicuous.

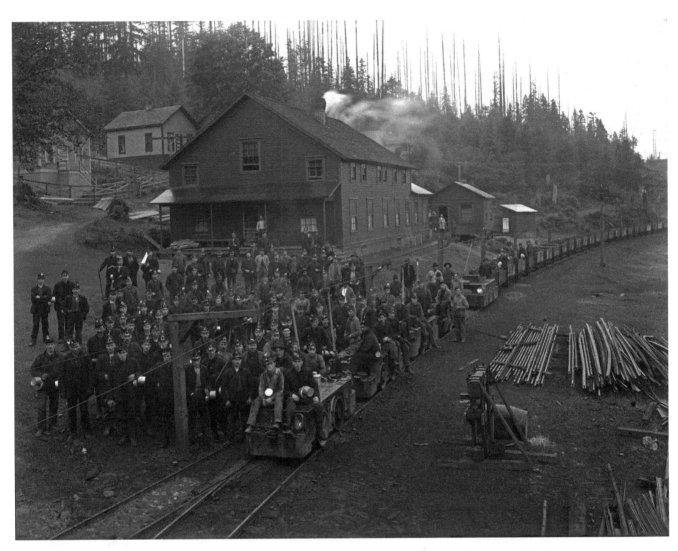

This 1909 photograph shows the morning shift of coal miners at the Coal Creek Mine at Newcastle, Washington. Newcastle was located near Renton, on Squak Mountain. Mining on the east side of Lake Washington was vital to the early growth of Seattle.

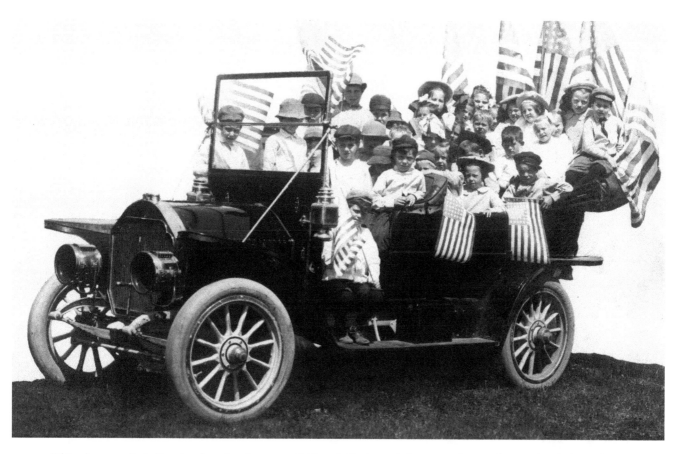

This photograph, believed to be taken between 1908 and 1915, spotlights more than 30 boys and girls from the Children's Industrial Home in Des Moines, Washington, just south of Seattle. The home operated from 1908 to 1927, serving hundreds of homeless and abandoned children. Herman and Annie Draper founded and ran the home and did it without government support.

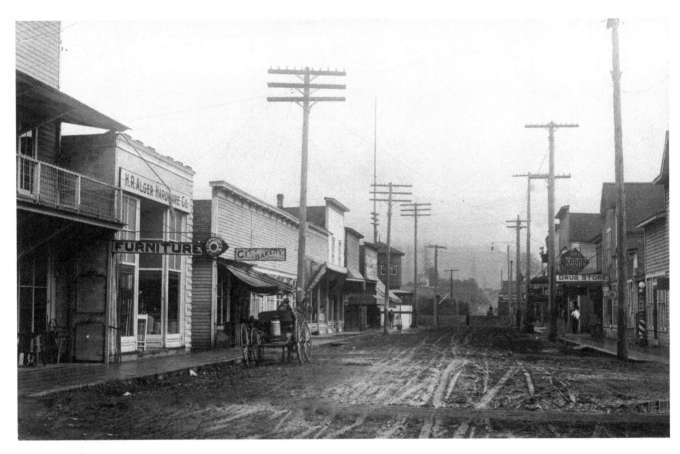

Cowlitz Avenue in Castle Rock, Washington, sometime before 1915. The unpaved streets and the horse-drawn wagon shed no clues that soon the automobile would begin to change the nature of these communities. A growing population was served by the furniture and hardware stores as well as by the local bakery.

Opportunity and Anxiety

(1910–1919)

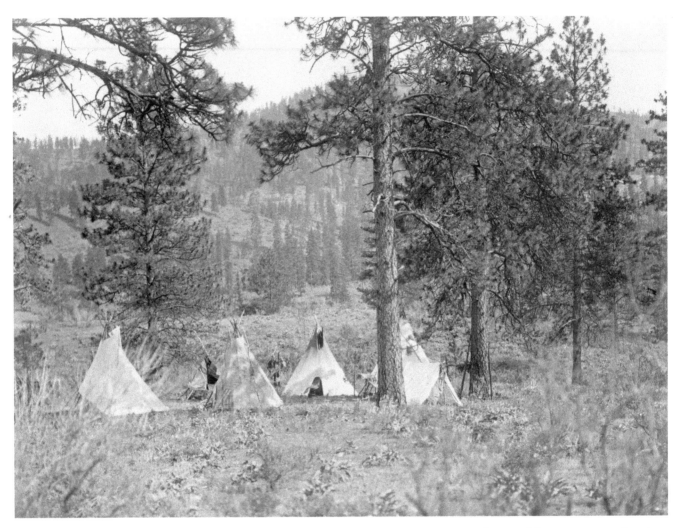

One of the most famous photographers of his era, Edward Curtis took this photograph around 1910 of five tepees somewhere in Washington State. Native Americans pursuing ancestral traditions continued to be an important part of the fabric of Washington life into the twentieth century.

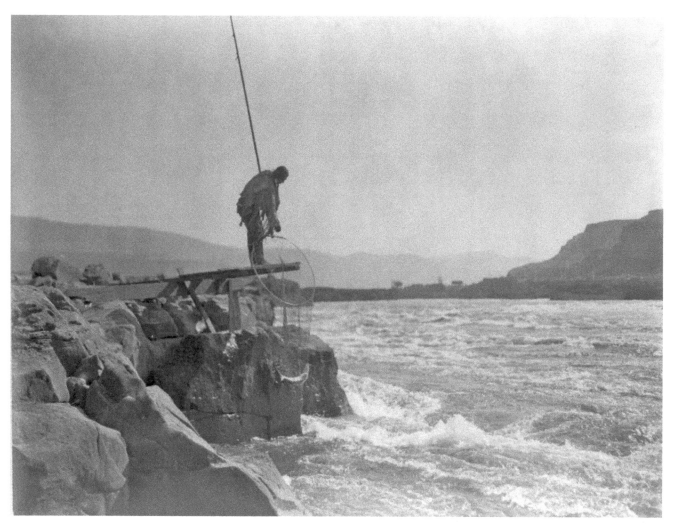

In this 1910 Edward Curtis photograph, a Tlakluit man is standing on the end of a frame platform with a netted fish that he has caught in the Columbia River. Before the construction of the many dams on the Columbia, anyone who chose to fish the river could make a living at it.

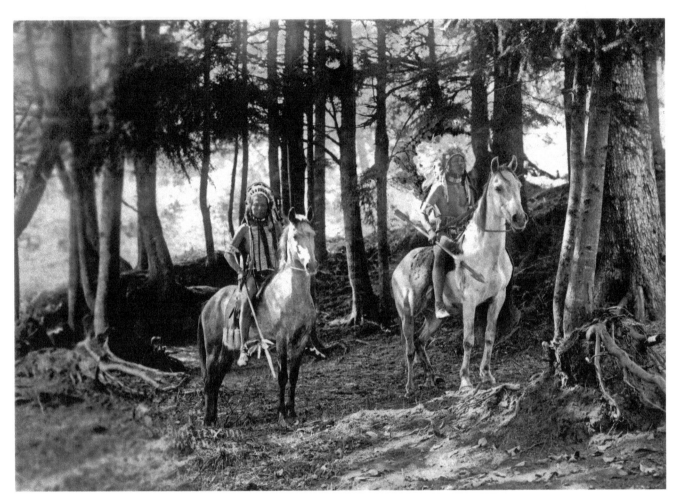

Two Yakama warriors on horseback pose for the photographer in 1911.

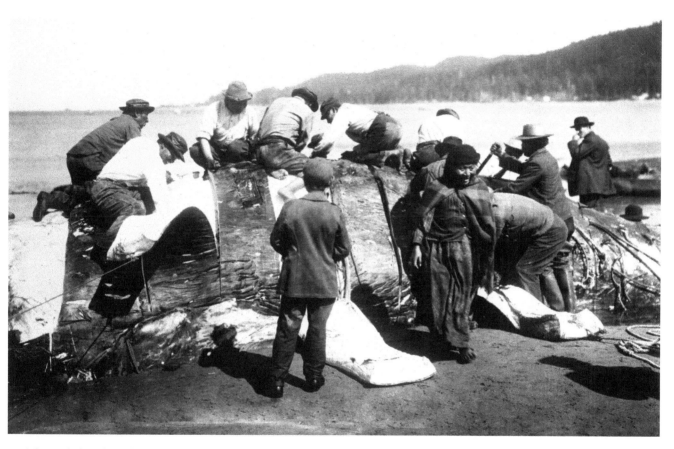

The Makah Indians have lived for centuries on the northwest tip of the Olympic Peninsula. Whaling had long been a principal part of their culture, both economically and spiritually, when Asahel Curtis made this photograph in 1910. In view here, a whale is being stripped of blubber, primarily by the men of the tribe.

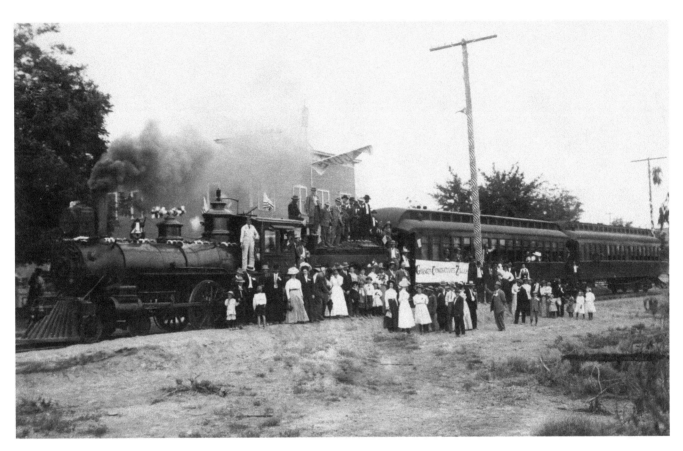

Local enthusiasm for the railroad is evident here in the small town of Zillah, Washington, in Yakima County. As the first train arrived on May 28, 1910, townsfolk gathered to celebrate what they hoped would be a life-giving link to the rest of the country.

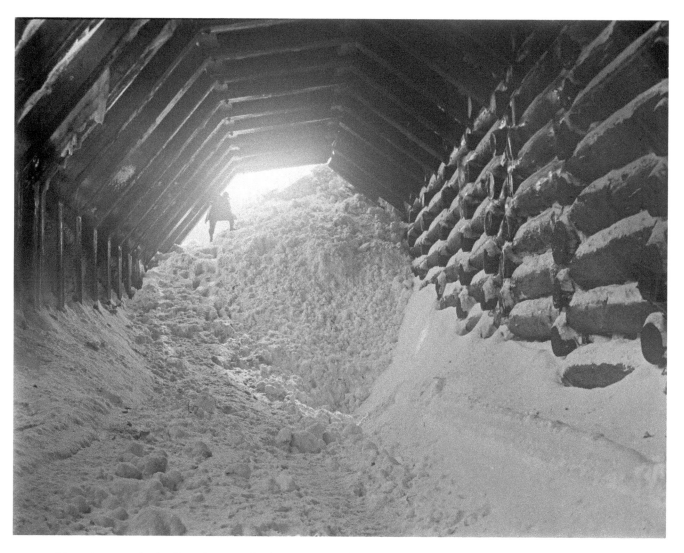

Managing snow in the Cascades proved to be a constant challenge. In this photograph of the Wellington avalanche, which occurred on March 1, 1910, the impact of the disaster is not readily evident. Two trains had been stalled while trying to negotiate Stevens Pass. An unanticipated avalanche struck both trains, sending them along with trees and boulders some 150 feet below into the Tye River Valley and killing 96 people.

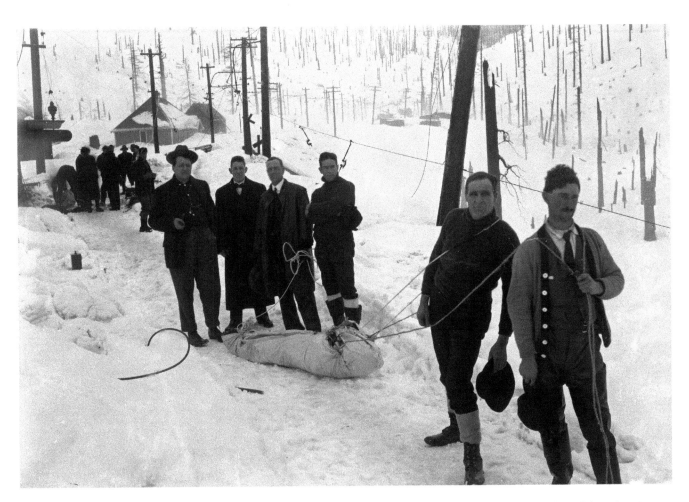

Following the Wellington avalanche, the recovery team that was assembled had to use sleds to bring the bodies of the 96 victims back to their grieving families.

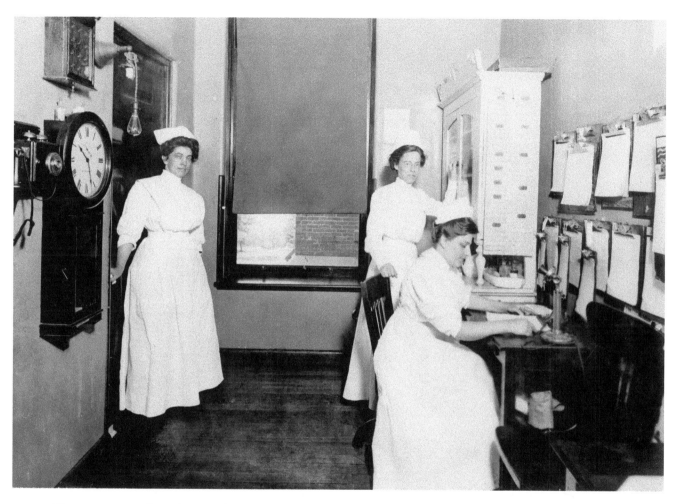

Three nurses pose for a photograph in 1911 in an office at the Northern Pacific Beneficial Association (NPBA) in Tacoma. Established in 1882, the NPBA was an effort to provide health care for railroad workers, who could enroll for a nominal premium. Hospitals were built along the railroad line, with Tacoma being the farthest west. Beginning in 1905, Tacoma began to accept patients and did so for the next ten years.

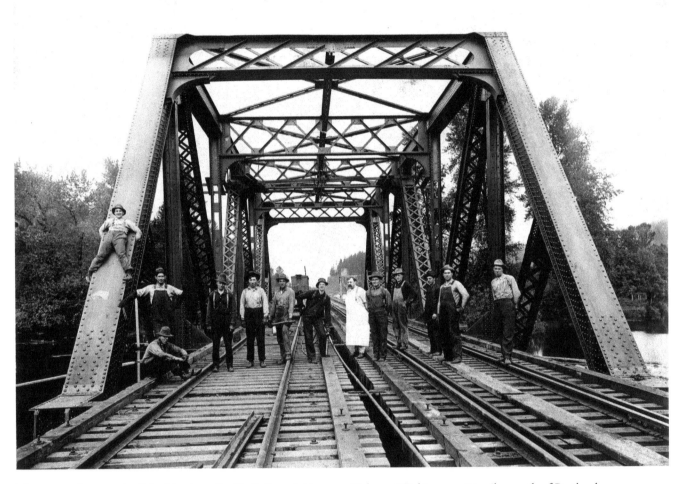

This 1911 photograph of the Northern Pacific Railway bridge near Kalama, Washington, 35 miles north of Portland, Oregon, reflects not only the importance of rail transportation, but also something of the life of working men early in the twentieth century.

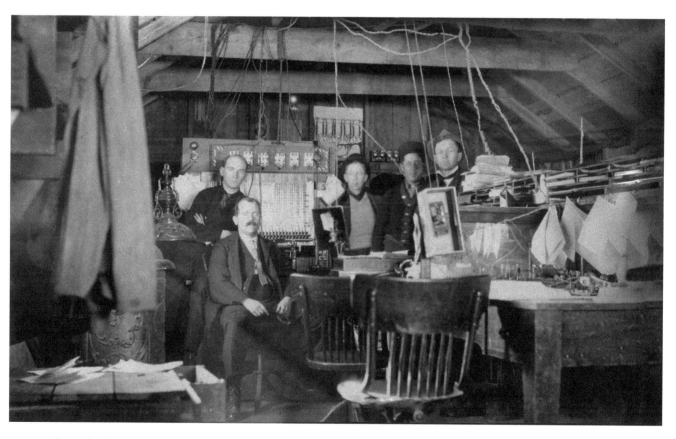

This is the dispatcher's office for the Chicago, Milwaukee, and St. Paul Railway yards in Malden, Washington, in Whitman County, near the town of Rosalia in eastern Washington.

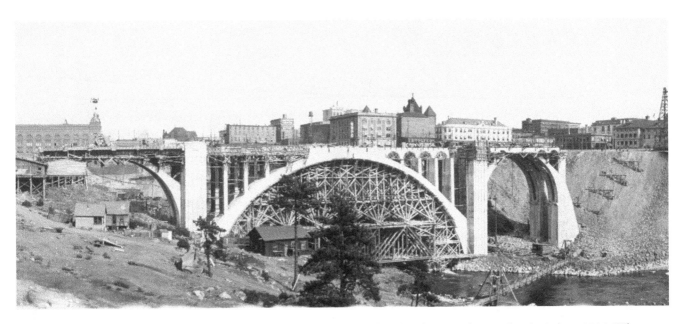

The third Monroe Street Bridge in Spokane would open three months after this photograph was taken in August 1911. When completed, the bridge was the largest concrete-arch bridge in the United States. Reconstructed in 2005 on plans faithful to the original, the new bridge honors the old as a cherished landmark in Spokane.

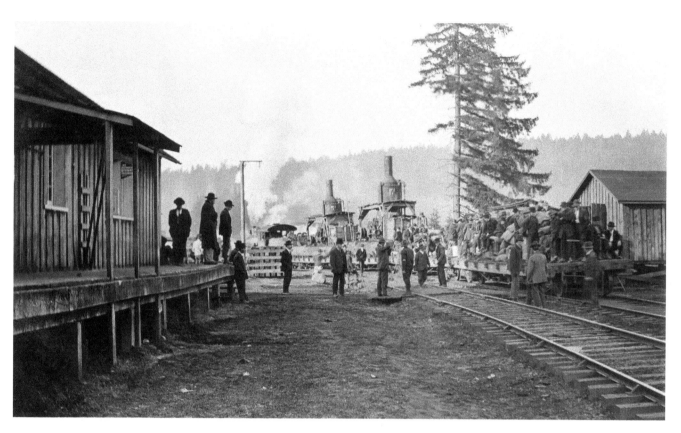

This 1912 photograph features loggers, jammed together on a railroad car, reaching camp at Yacolt, Washington. Two donkey engines are visible in the background. These steam-powered engines enabled a logger to attach a cable to a log. When signaled by the operator, the donkey engine dragged the log to a mill or designated landing where it could be loaded onto a railroad car.

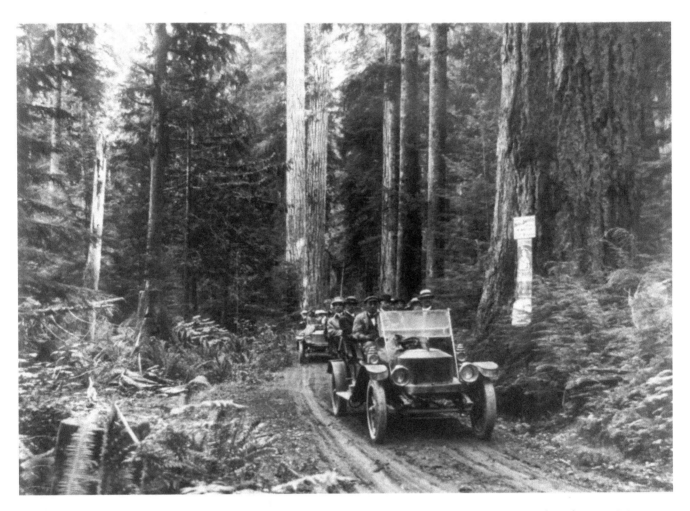

Tourists in two open-air cars travel a dirt road in the Olympic National Forest, past advertisements posted on the trees. It is likely that these people are en route to the Sol Duc Hot Springs resort, which opened in 1912 on the peninsula—the year this photograph was taken. The elaborate resort included a 165-room hotel, a large bathhouse, a gymnasium, and a golf course. It burned in 1916.

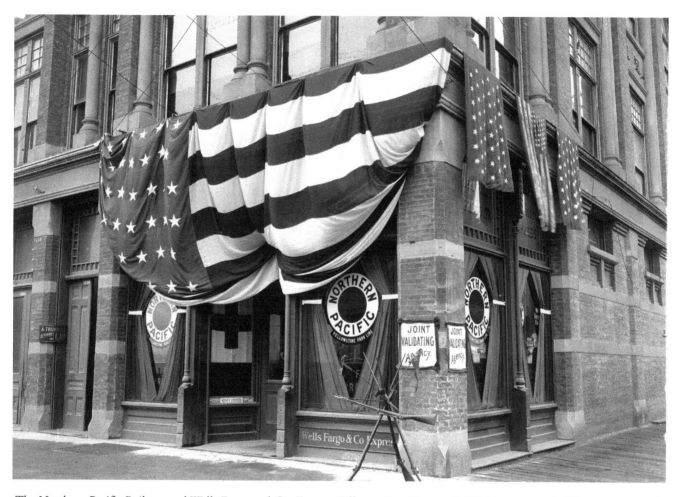

The Northern Pacific Railway and Wells Fargo and Co. Express Office in Port Townsend, Washington, on the Olympic Peninsula. Once called the "City of Dreams," Port Townsend became a bustling community in the late nineteenth century filled with Victorian homes that reminded one of San Francisco.

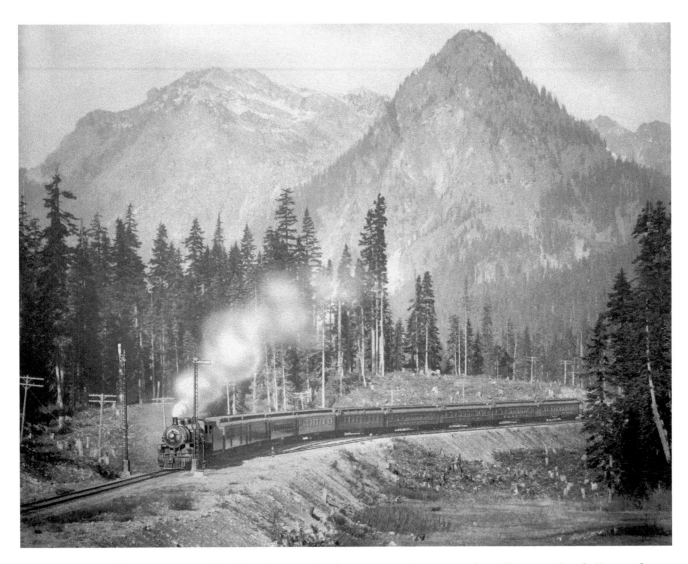

The Olympian, of the Milwaukee Road, is shown here on October 13, 1913. Its route ran from Chicago to Seattle-Tacoma from 1911 to 1961. The name "Olympian" was chosen as a result of a public contest and was given to the fastest of two new trains inaugurated in 1911. The other, slower train was named the "Columbian."

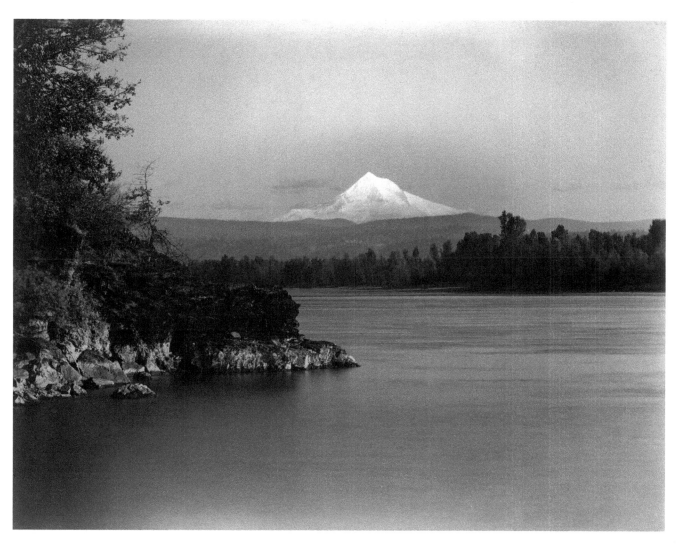

Washington residents on the north side of the Columbia River near Portland have always enjoyed the beautiful vistas of Mount Hood, the tallest mountain in Oregon.

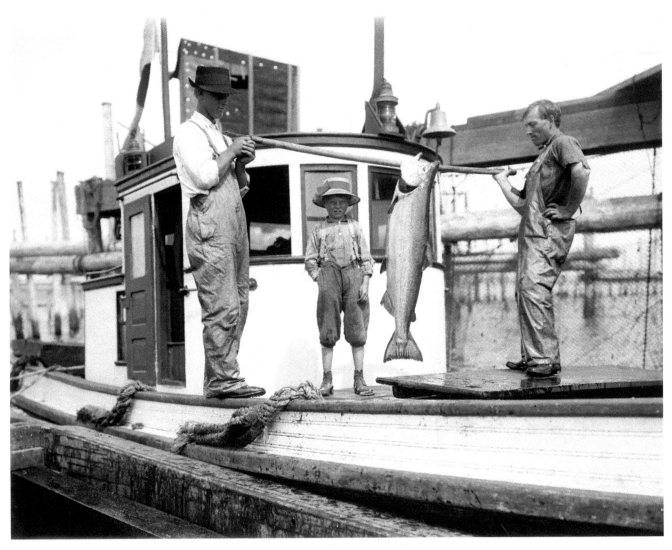

This 1913 photograph of a large salmon on a fishing boat points up the importance of salmon fishing to Washington's economy and northwest culture.

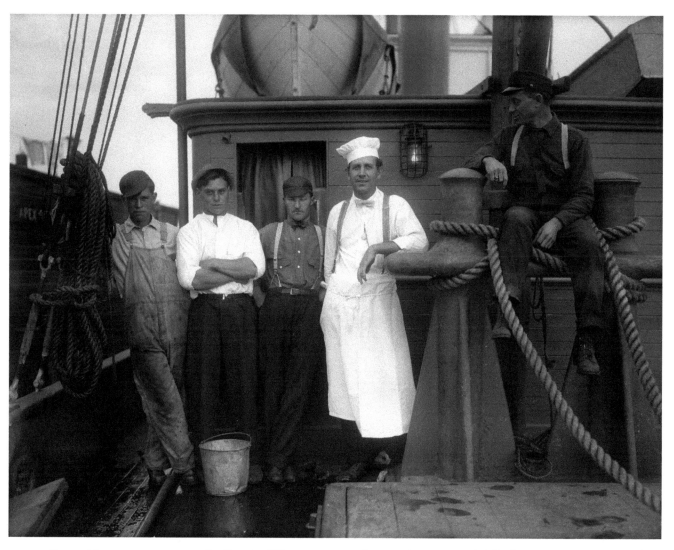

Crew of the motor cannery tender *Superior*. Life on a cannery ship was dangerous and difficult. Often poorly paid, workers scratched out a living.

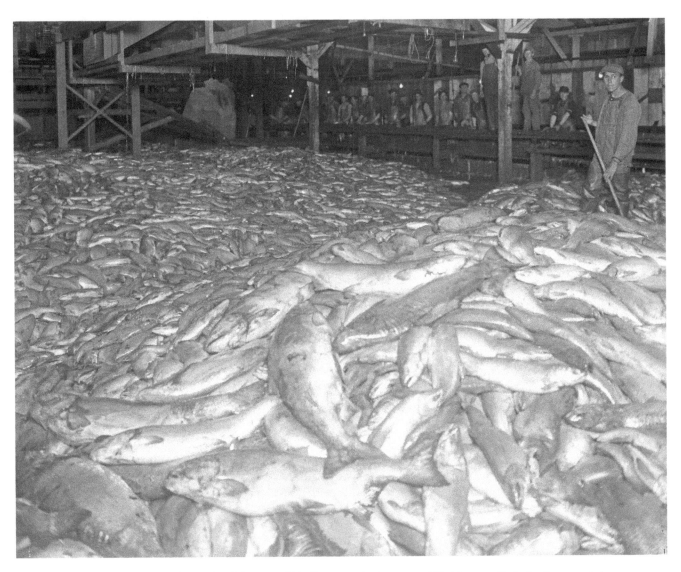

This 1913 photograph features the inside of the Apex Fish Company in Anacortes, Washington. Early in the twentieth century, Anacortes was known as the "Gloucester of the Pacific." Six salmon canneries in Anacortes canned more salmon than any other city in the world.

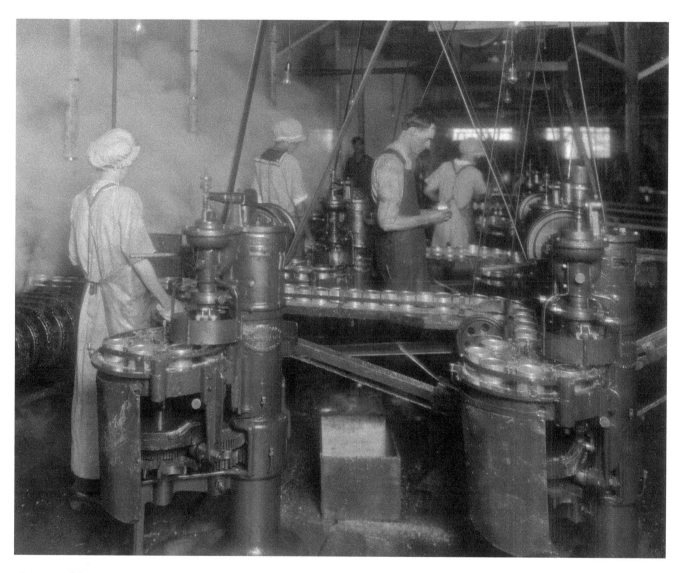

Interior of the Apex Fish Company in Anacortes. Mechanization enabled workers to produce thousands of cases in a single day. It was once estimated that the six canneries in Anacortes produced enough cases in a ten-hour workday that if stacked end on end, the cans would tower 20,500 feet.

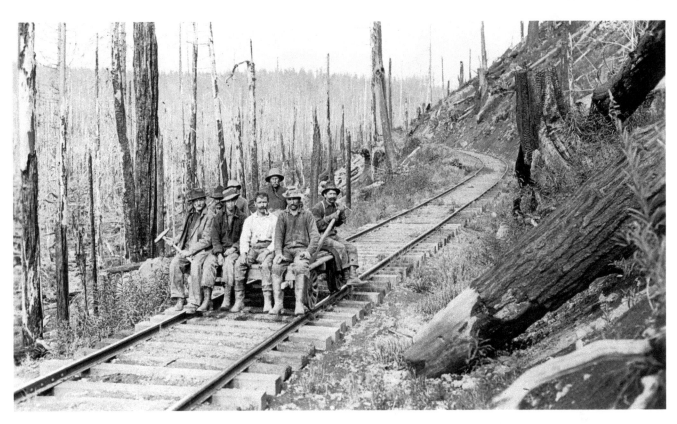

Eight loggers sit on a railcar, sometimes known as a speeder car, as they work to recover as much timber as possible from the devastating forest fire of 1902 in southwestern Washington.

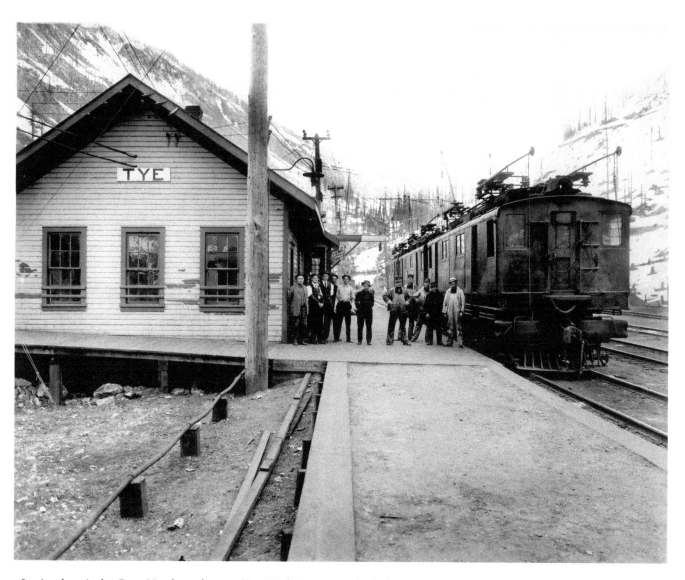

In view here is the Great Northern depot at Tye, Washington, as it looked in 1913. Tye was originally called Wellington, but after the horrible avalanche of 1910 that killed 96 people, the name of the town was changed. Tye was abandoned in 1929 when a second Cascade tunnel came into use.

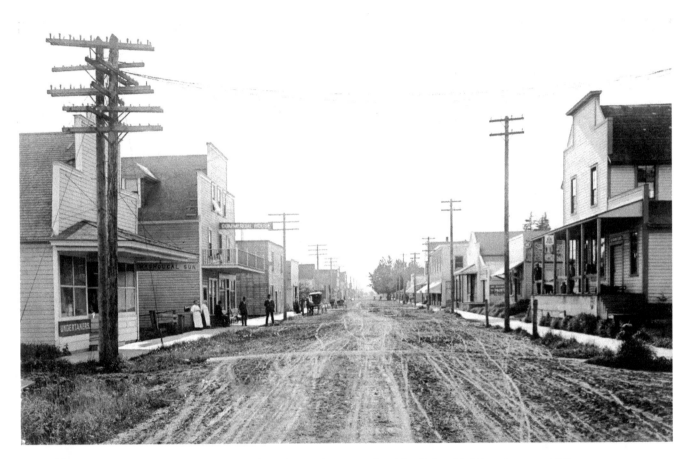

Main Street in Washougal, Washington. Located on the Washington side of the Columbia River, just east of Vancouver, Washougal was incorporated in 1908. Its name was derived from the Chinook words for "Rushing Waters." This photograph shows the unpaved streets but the growing commercial activity of the early twentieth century.

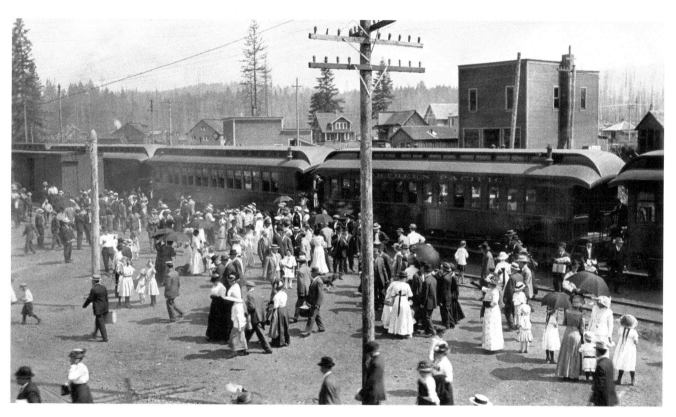

This July 4th scene from 1913 was typical of many communities in Washington. Families here have taken the train for an outing to Yacolt, in the southwestern part of the state. Washington's growing middle class, embodying Victorian cultural trends, is reflected in this photograph.

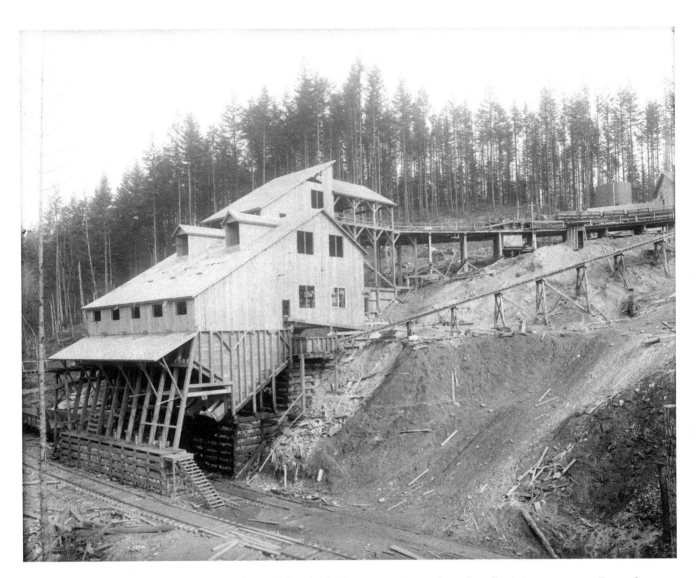

Cumberland Mine in King County in March 1914. Cumberland was one of a number of small mining towns near Enumclaw in southern King County. Other towns included Bayne, Occidental, Elkcoal, Hiawatha, and Kangley. Most of these mines, including Cumberland, were closed after the demand for coal dropped following World War I.

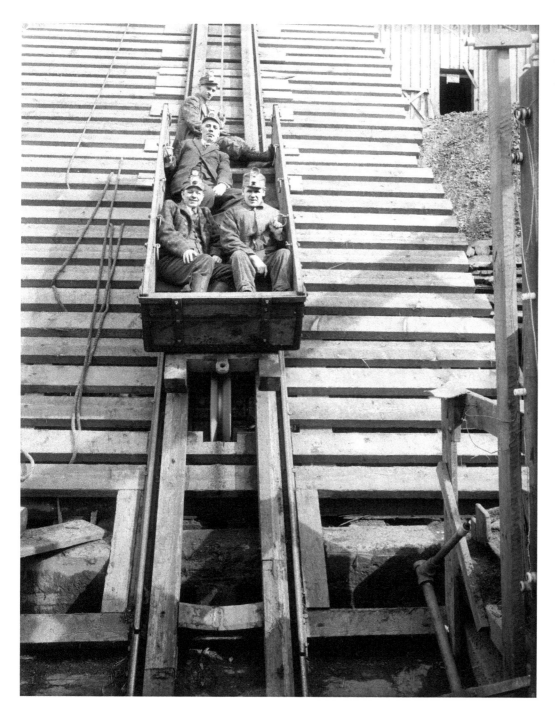

Coal miners exit the Cumberland Mine near Enumclaw in 1914.

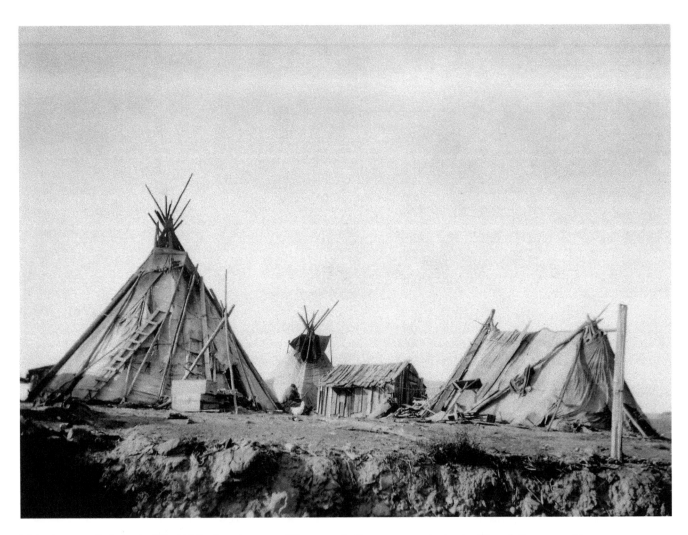

This photograph from the World War I era features a Wanapum Indian camp on the bank of Lyon's Ferry near Vantage, Washington, on the Columbia River in the middle of the state.

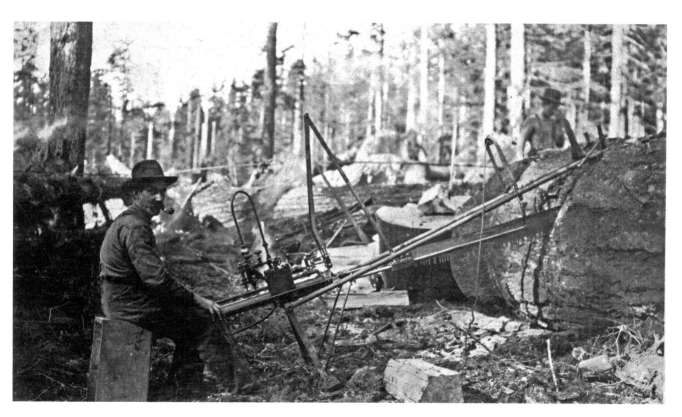

This 1913 photograph features two loggers using a powered draw saw.

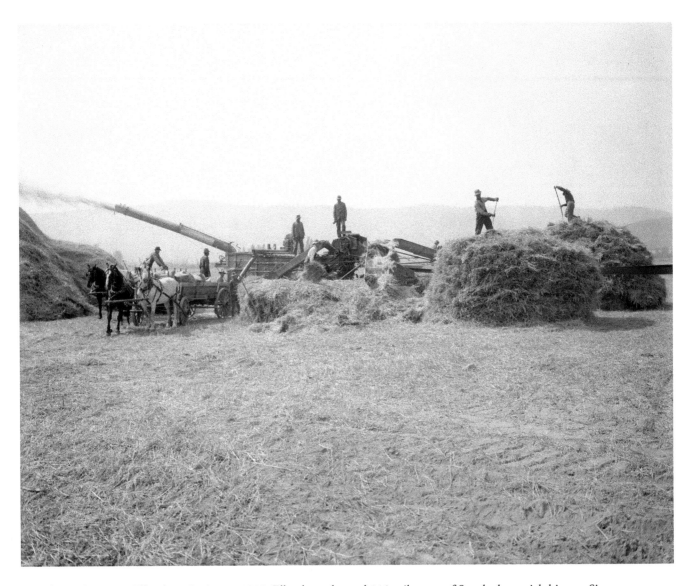

Threshing wheat near Ellensburg in August 1915. Ellensburg, located 110 miles east of Seattle, has a rich history. Site of early cattle drives through the state, Ellensburg became known for its rodeo, but agriculture has been a staple of its economy. Evident here is the increasing reliance on mechanization, which helped make agriculture profitable.

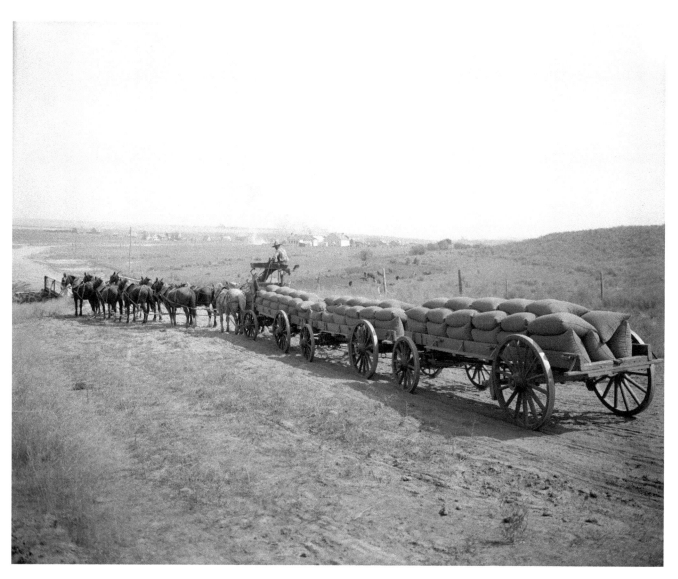

In 1915, horses were still heavily used throughout the state for transporting sacks of wheat to the railroad lines.

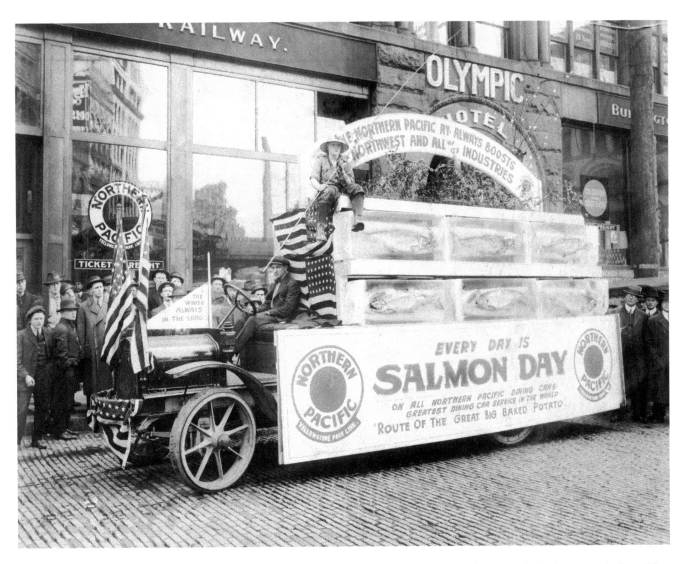

"Every day is salmon day on all Northern Pacific dining cars" runs the ad on this 1915 Northern Pacific Railway parade float. The float, in downtown Seattle in front of the Olympic Hotel, was a promotion for the railroad and the sale of salmon.

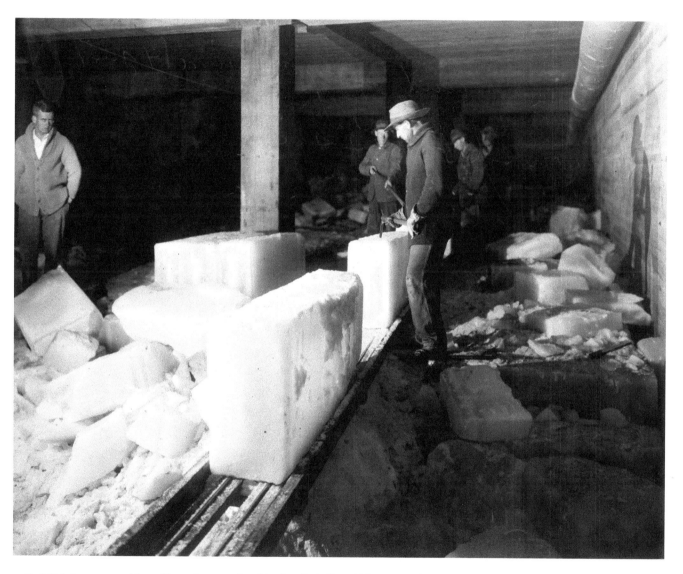

In 1915, ice was used in refrigeration cars for shipping fruit from Yakima to other parts of the nation. The production of ice was vital to the agricultural industry.

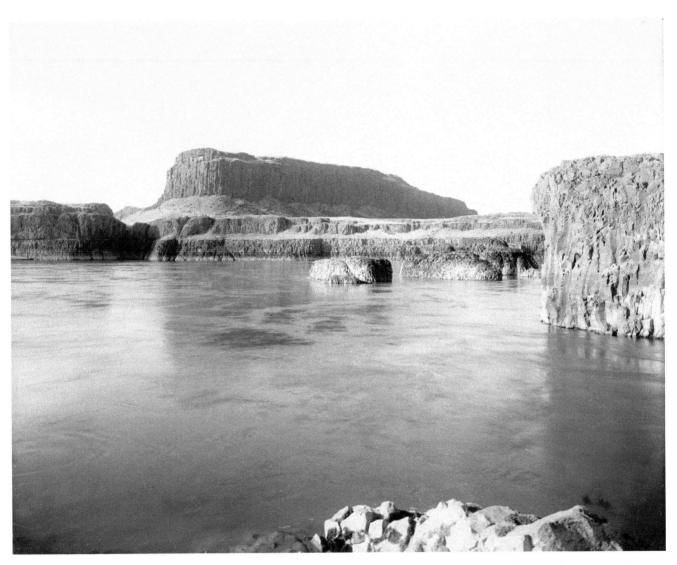

This 1915 photograph features Horsethief Butte on the Columbia River near the Cascade Locks. Today part of the Columbia Hills State Park, some of this area was flooded following construction of the Dalles Dam in 1957.

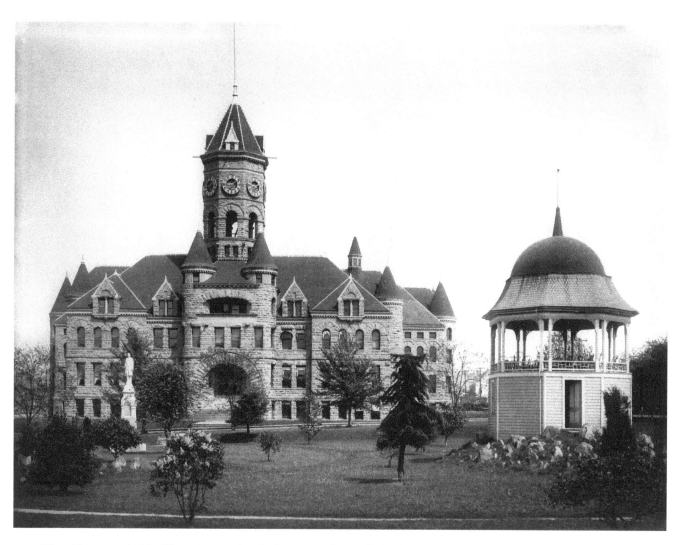

The old state capitol in Olympia sometime before 1920. Originally built in 1892, it was constructed out of Chuckanut stone from Whatcom County. During its first 13 years, the building served as the Thurston County Courthouse and was known for its 150-foot-tall octagonal clock tower with clocks on all eight sides. Beginning in 1905, the state legislature met in the building until today's legislative building was completed in 1928.

A group of men and women climb Paradise Glacier in Mount Rainier National Park sometime before 1920. Aside from revealing what appears to be a remarkably dangerous route up the mountain, the photograph is evidence of changing social patterns. The "New Woman," as she was often referred to early in the twentieth century, was pushing traditional boundaries.

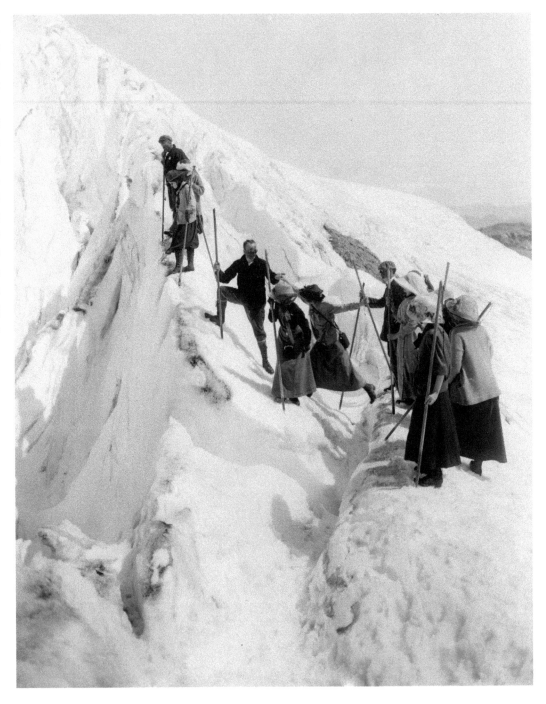

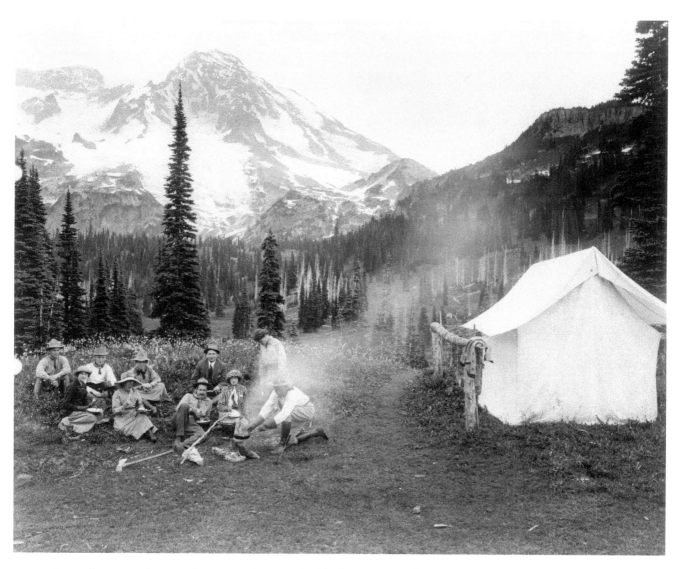

A camping party of men and women enjoy a meal cooked over an open fire near the Indian Henry Campground in Mount Rainier National Park sometime before 1920.

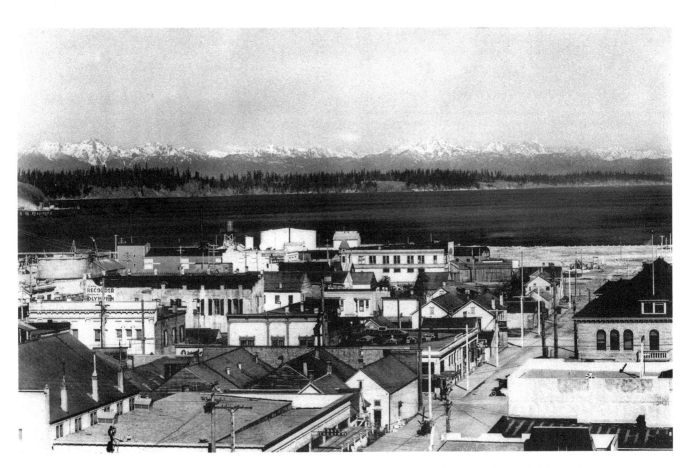

This photograph of Olympia in 1916 showcases the stunning scenery of Puget Sound and the Olympic Mountain range.

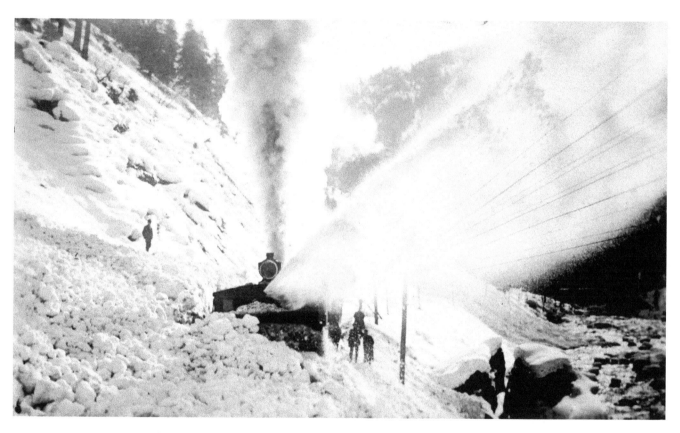

A rotary snowplow clears the tracks for the Great Northern Railway in Tumwater Canyon near Leavenworth around 1917. Avalanches were a perennial danger for the railroads in the Cascade Mountains.

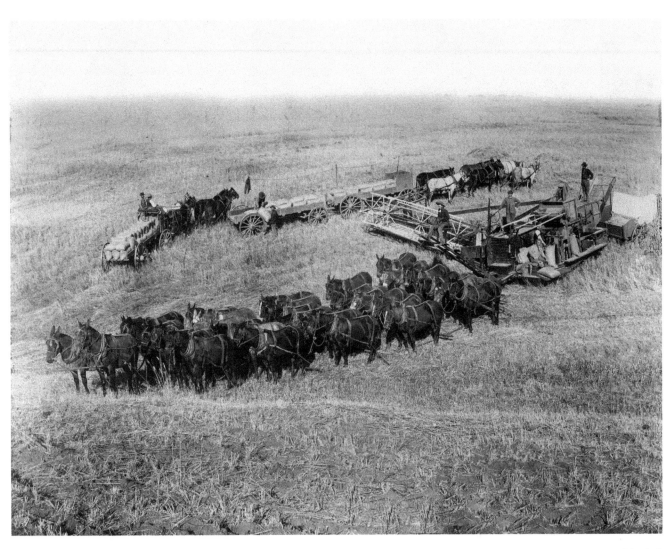

A combined header and thresher is pulled by a 32-horse team on a ranch near Big Bend, Washington. Requiring considerable skill to drive, this thresher was often at risk of overturning.

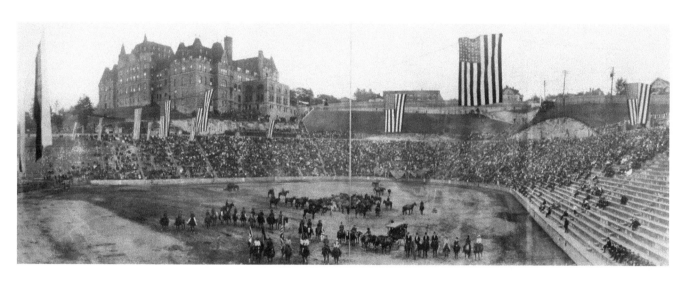

On July 4, 1918, soldiers stationed at Camp Lewis organized an exhibition of military horsemanship at the Tacoma Stadium under the shadow of Stadium High School. The Tacoma Stadium could originally seat somewhere between 23,000 and 40,000 spectators and was the site of many public events in the first half of the twentieth century. Stadium High School opened in 1906 and to this day remains a landmark for the city of Tacoma.

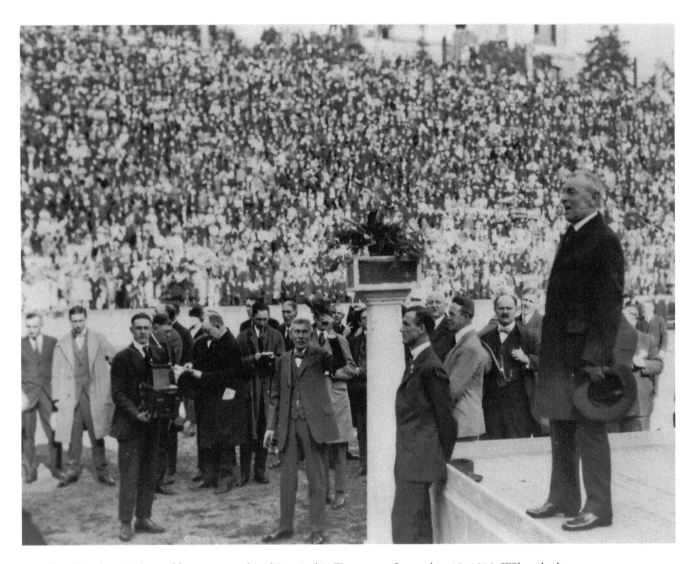

President Woodrow Wilson addresses a crowd on his arrival in Tacoma on September 18, 1919. Wilson had come west to help promote his idea for a League of Nations and ratification of the Treaty of Versailles. Wilson may have been on the verge of exhaustion; he collapsed in Pueblo, Colorado, on September 25 and then suffered a serious stroke that incapacitated him on October 2.

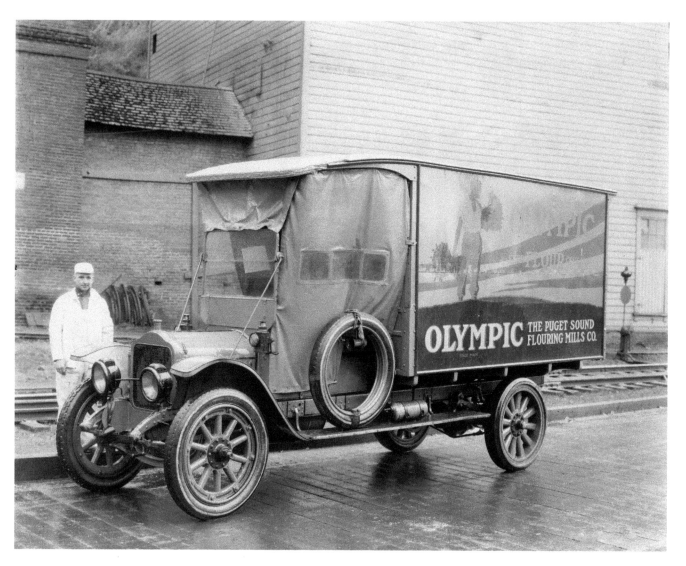

In 1919, an employee for the Puget Sound Flouring Mills Company of Tacoma, Washington, poses beside his delivery truck for a photograph. The transportation revolution of assembly-line automobiles, and trucks like this one, would have a great impact on the state's economy.

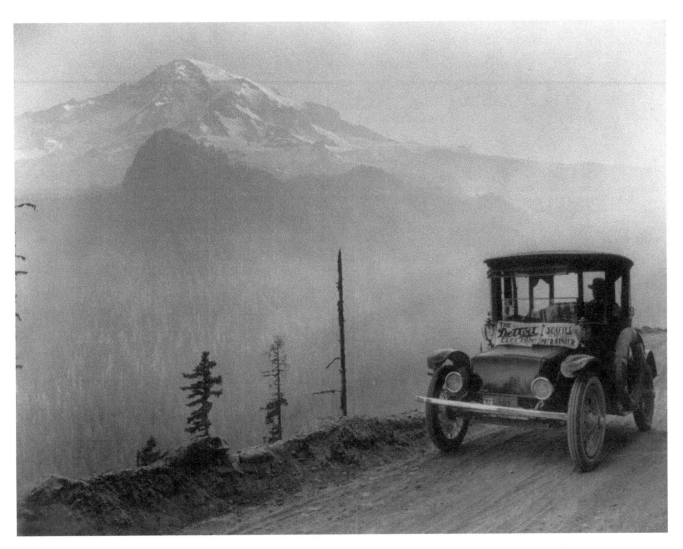

This 1919 photograph of a Detroit Electric car going from Seattle to Mount Rainier reflects the importance of the automobile to the growing tourist industry in Washington. At its peak in the 1910s, the Detroit company sold between 1,000 to 2,000 cars a year, not shipping the last one until 1939. With a top speed of 20 miles per hour, the car reportedly ran 80 miles on one charge, although in one test it exceeded 200. Many notable individuals owned the Detroit Electric, including Thomas Edison and John D. Rockefeller, Jr.

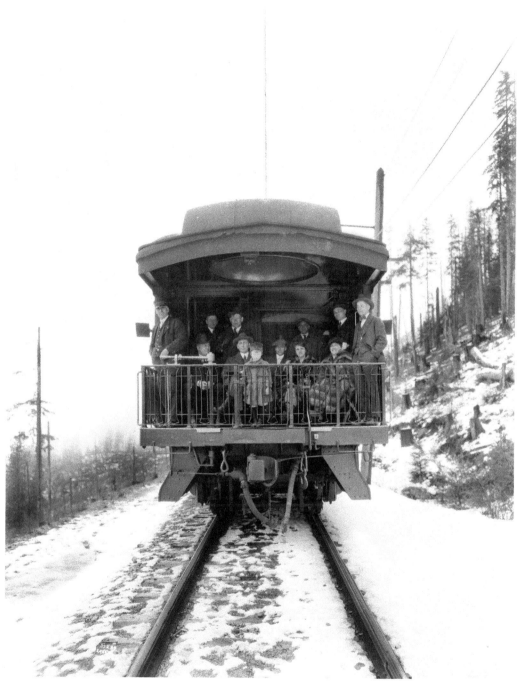

Travelers on the Chicago, Milwaukee, & St. Paul Railway number 16 pose for a photograph near Cle Elum, Washington, in 1920.

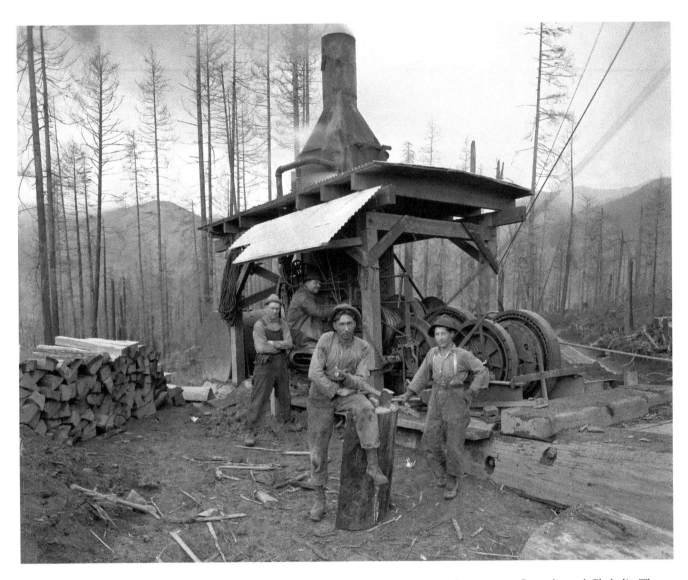

Four loggers and a steam donkey engine at the West Fork Logging Company in Lewis County near Centralia and Chehalis. The donkey engine was instrumental in making possible the logging of forests in difficult terrain.

Between the Two Wars

(1920–1939)

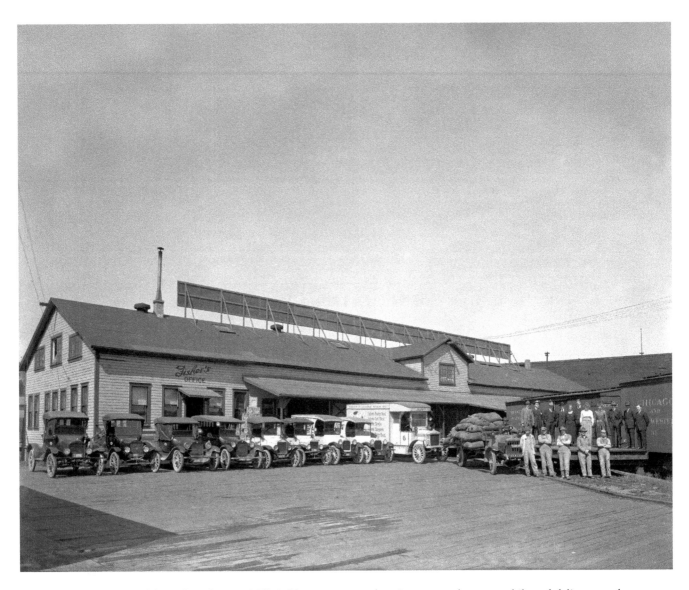

This 1920 photograph of the Fisher Flouring Mills in Tacoma suggests how important the automobile and delivery truck were becoming to the Northwest's economy.

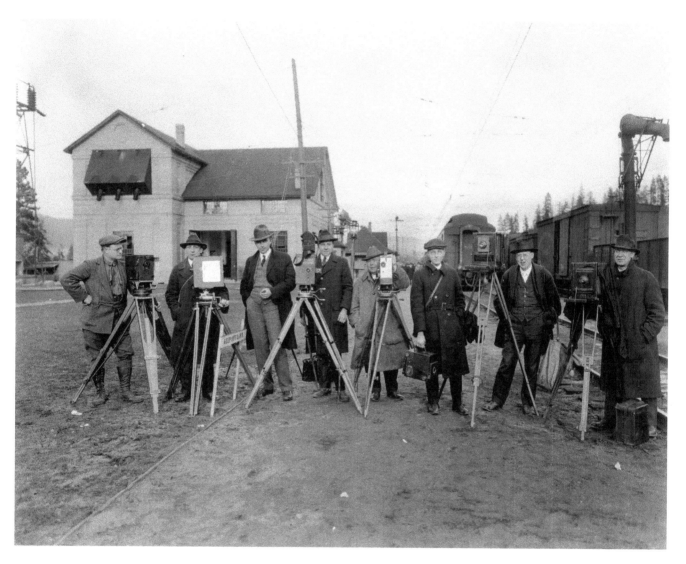

Newsreel photographers document the March 5, 1920, opening of the 207-mile Chicago, Milwaukee, & St. Paul Railway Coast Division electrification substation at Cle Elum. The national media itself was rising to prominence in the post–World War I era.

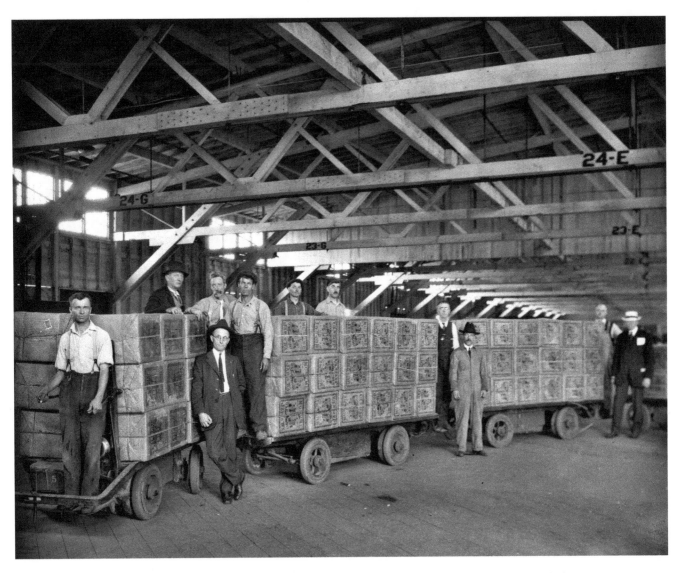

Workers prepare to load crates of Musume brand Japanese tea onto Milwaukee Road freight cars. Trade with the Far East continued to grow in the years after World War I.

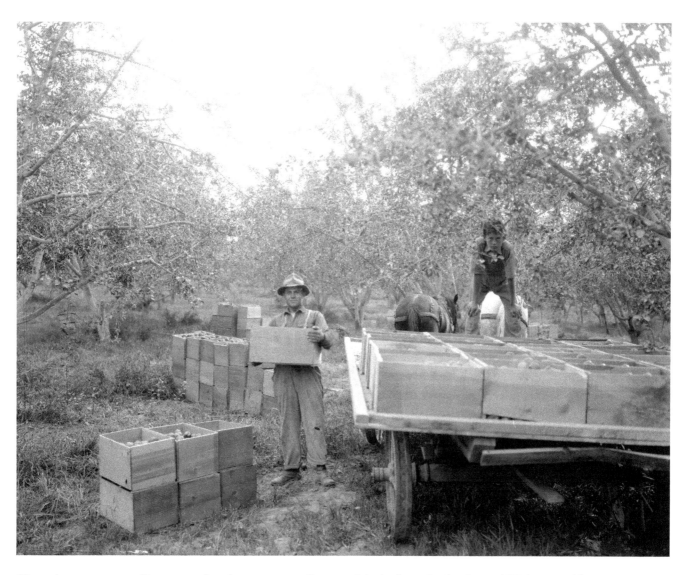

Horse-drawn wagons pulling crates of apples were once a frequent sight in the orchards of central Washington. This is a 1921 view of the Curtis Orchard in Grandview, 35 miles west of the Tri-cities.

Silent-movie star Ben Turpin, famous for his crossed eyes, poses at a Northern Pacific Railroad office in Seattle in 1923. Northern Pacific dining cars featured what they called the "Great Big Baked Potato," some of which are tantalizing Turpin and his associates.

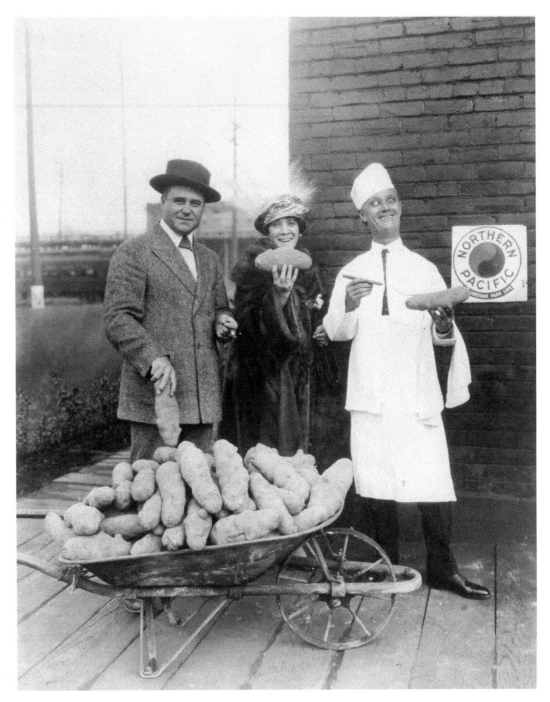

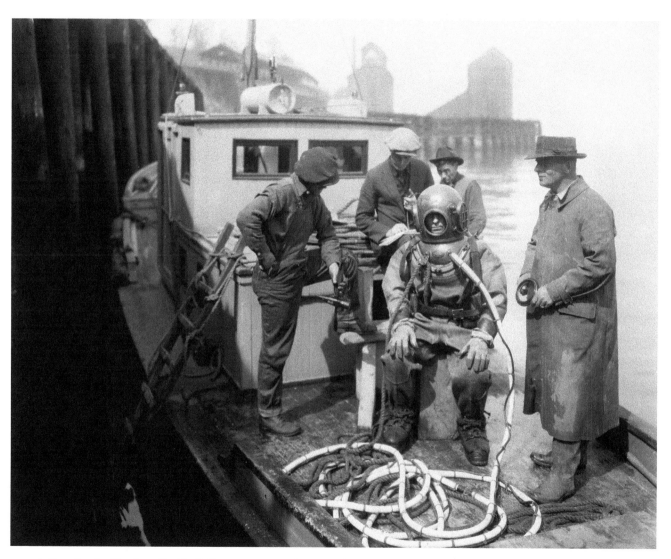

A diver for the Northern Pacific Railway prepares to inspect pilings in Commencement Bay at Tacoma, Washington, in 1924.

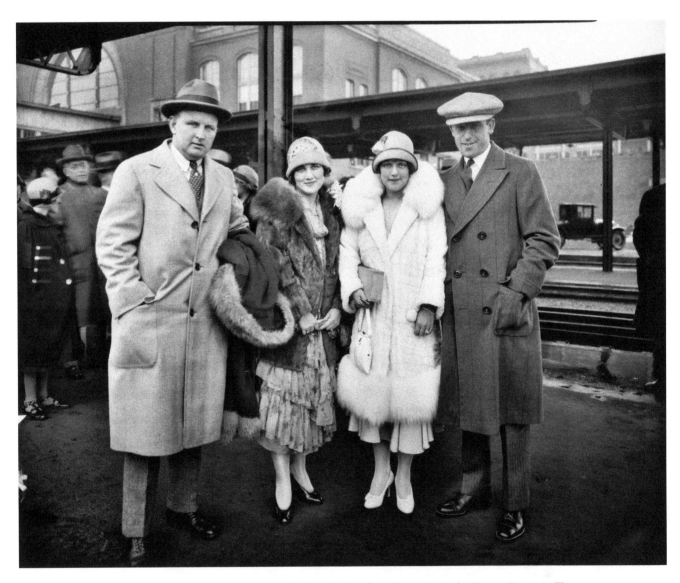

Movie stars Mildred Davis, third from the right, and Harold Lloyd at far right arrive at the Union Depot in Tacoma, Washington, in 1925. Along with Buster Keaton and Charlie Chaplin, Lloyd would emerge as one of the most famous silent-film comedians of his era.

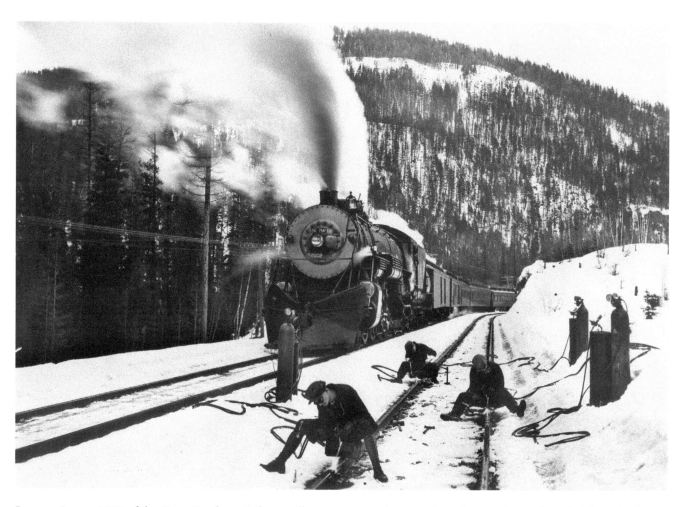

Locomotive no. 2502 of the Great Northern Railway pulls a passenger train somewhere along a wintery Cascade Mountain Range. Under way on the tracks opposite, track repair was a constant need.

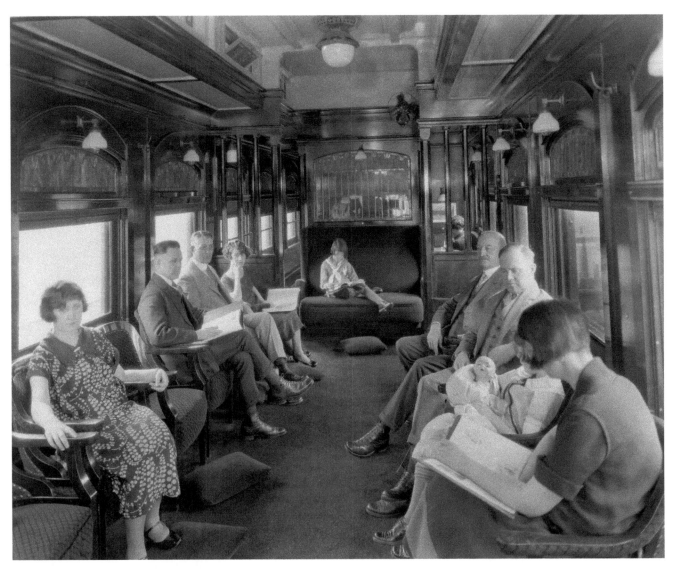

Travelers relax in the observation car on the Milwaukee Road's Olympian. Taken in 1925, this photograph is evidence of a "golden age" for passenger trains, which increasingly helped connect Washingtonians to other parts of the nation.

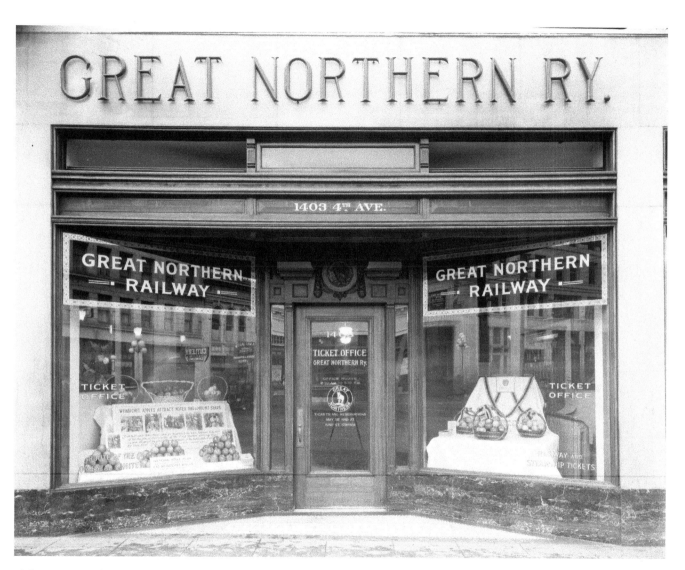

The Great Northern Railway office in Seattle advertises Wenatchee apples and National Apple Week in its front window in 1925.

One of the most famous icons in America during the 1920s was Babe Ruth. Shown here in 1926, Ruth shakes hands with an engineer for the Milwaukee Road while visiting the Pacific Northwest. They stand in front of a gearless bipolar locomotive constructed by General Electric in 1919.

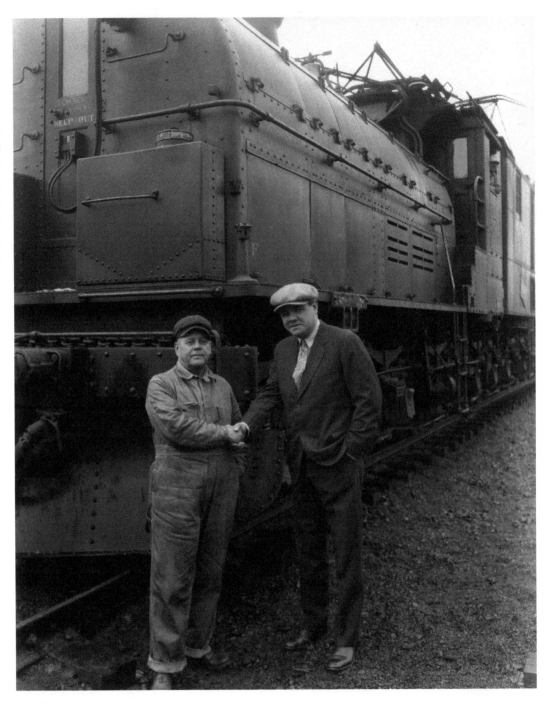

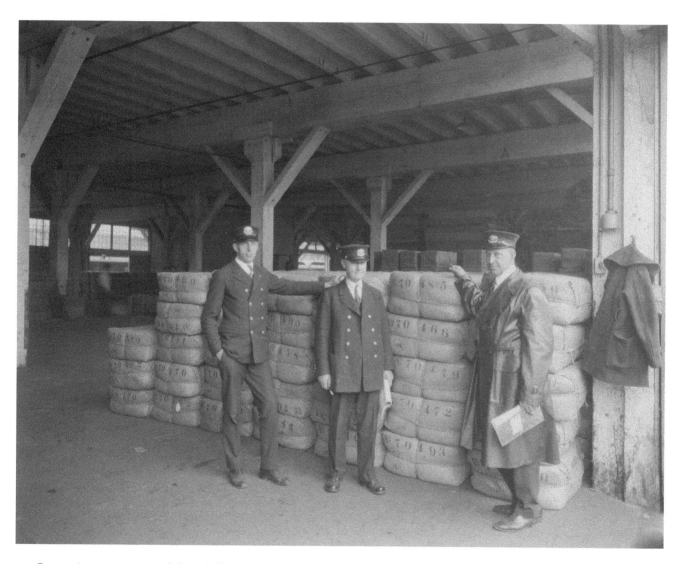

Custom inspectors oversee bales of silk. Special silk trains ran from Seattle and other West Coast cities to the Midwest and East Coast from 1912 to 1933. Competition with the Canadian Railroad was fierce; silk trains were specially prepared and given priority over other trains in order to expedite the service.

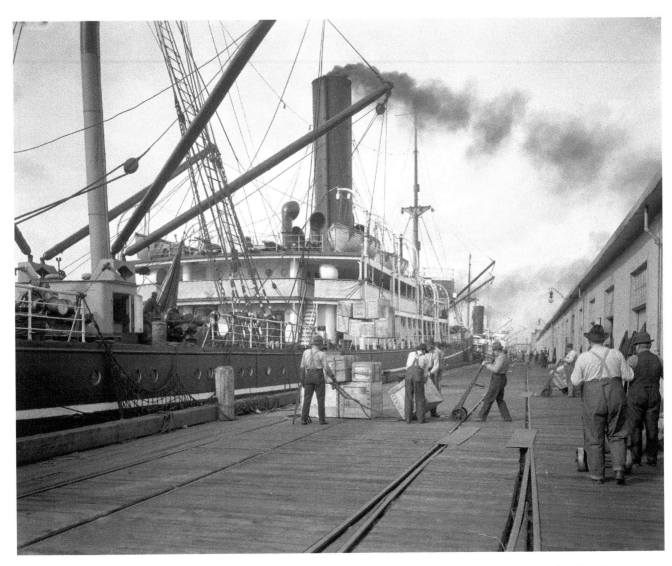

Longshoremen work on the Great Northern docks in Seattle in 1926. In 1934, longshoremen up and down the West Coast went out on strike in a bitter labor dispute.

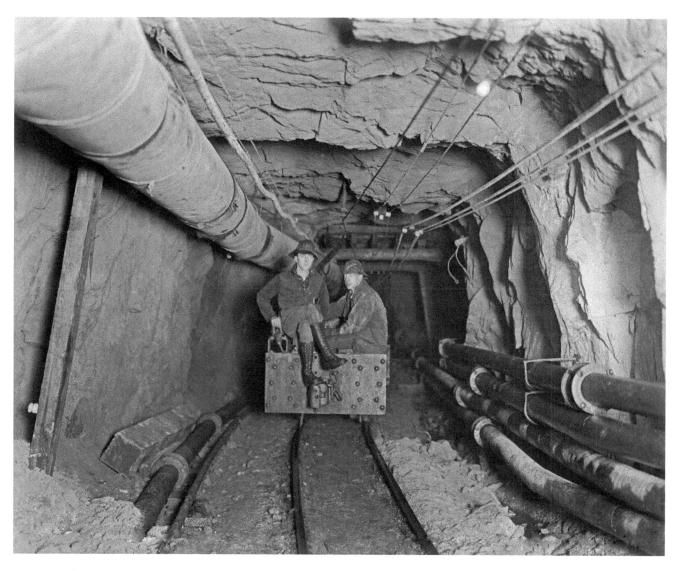

The construction of the New Cascade Tunnel near Stevens Pass was difficult but deemed essential to avoiding avalanches like the one at Wellington in 1910 which had claimed the lives of so many passengers. In this 1928 photograph, workers are shown along with ventilator pipes, designed to blow fresh air into the tunnel. At nearly eight miles in length, the tunnel was completed in 1929 and remains the longest railroad tunnel in the United States.

This 1928 photograph features a large number of construction workers of the Diablo Dam on the Skagit River. Diablo was completed in 1930 and at that time was the tallest dam in the world at 389 feet. The Diablo, Gorge, and Ross dams still provide approximately 25 percent of the electric power for Seattle.

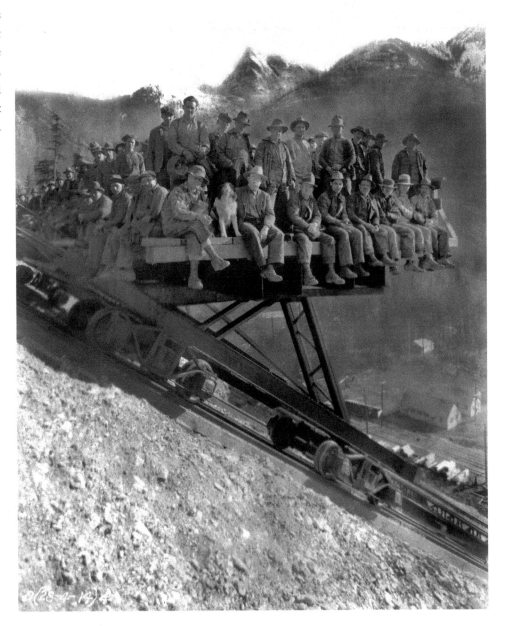

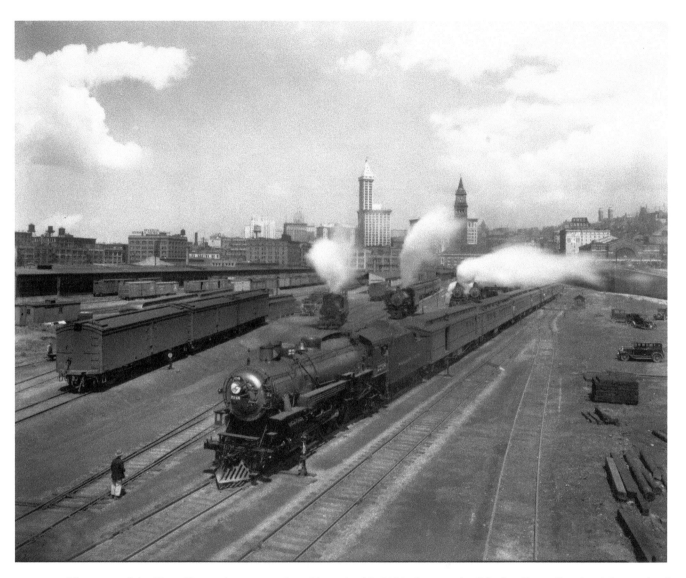

The onset of the Great Depression was not in evidence in this 1930 photograph of the bustling railroad activity south of downtown Seattle. The Smith Tower, in the center, and the King Street Station, on the right, were two of the city's most distinctive landmarks. At 462 feet tall, when the Smith Tower was dedicated on July 4, 1914, it was the tallest building west of Ohio.

Indians engage in fishing in the 1930s at Celilo Falls on the Columbia River, one of the most important gathering places on the Columbia for Indians of the Plateau culture for thousands of years. The construction of the Dalles Dam in 1957 inundated this particular part of the Columbia, generating a huge controversy.

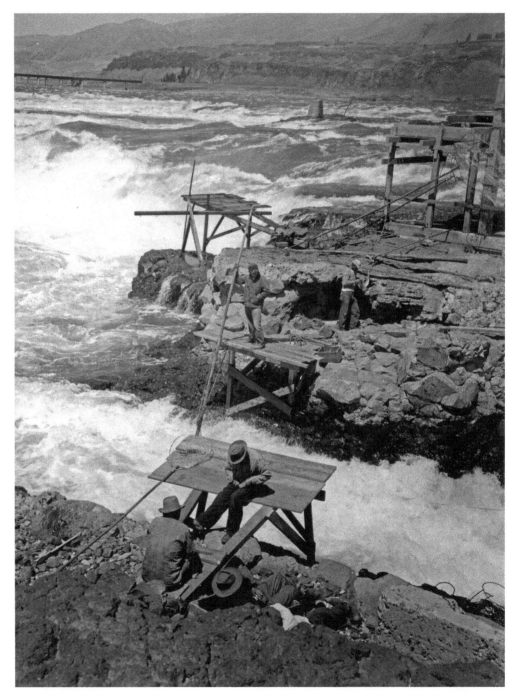

World War II and the Making of Modern Washington

(1940–1950s)

The first Tacoma Narrows Bridge is shown here during construction in 1940. The desire to build a bridge across the southern Puget Sound narrows from Tacoma to the Olympic Peninsula began in the 1880s when the Northern Pacific first proposed a trestle. Momentum picked up in the 1920s and funds were approved in the 1930s. The bridge opened on July 1, 1940.

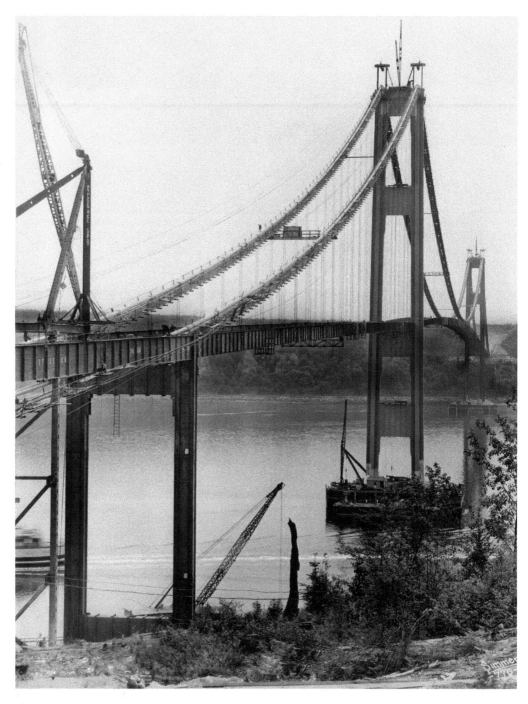

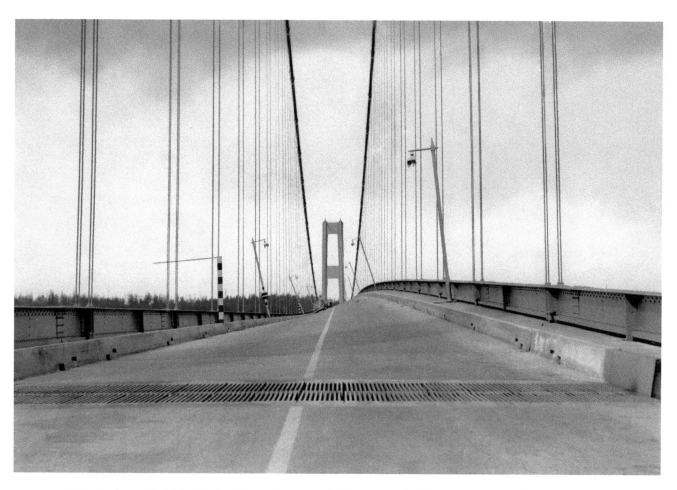

When it opened in 1940, the first Tacoma Narrows Bridge was the third longest suspension bridge in the world. Almost immediately, the bridge began to sway in the face of strong winds and was soon nicknamed "Galloping Gertie." Finally, on November 7, 1940, the bridge collapsed in a spectacular fall that was caught on film. Those on the bridge at the time were able to escape, but a small dog could not and became the only casualty.

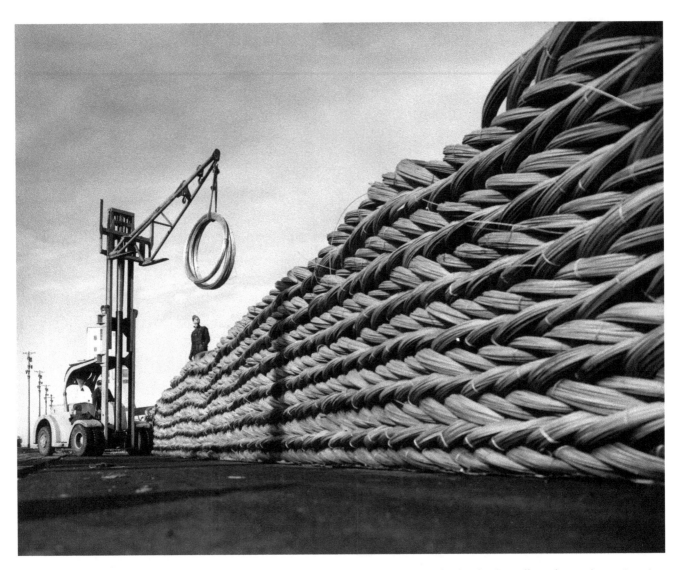

These rolls of wire were used to construct the second Tacoma Narrows Bridge. After the first bridge collapsed in 1940, engineering standards changed. The second bridge was designed not only with greater strength, but also with trusses that allowed the wind to pass through without affecting the bridge.

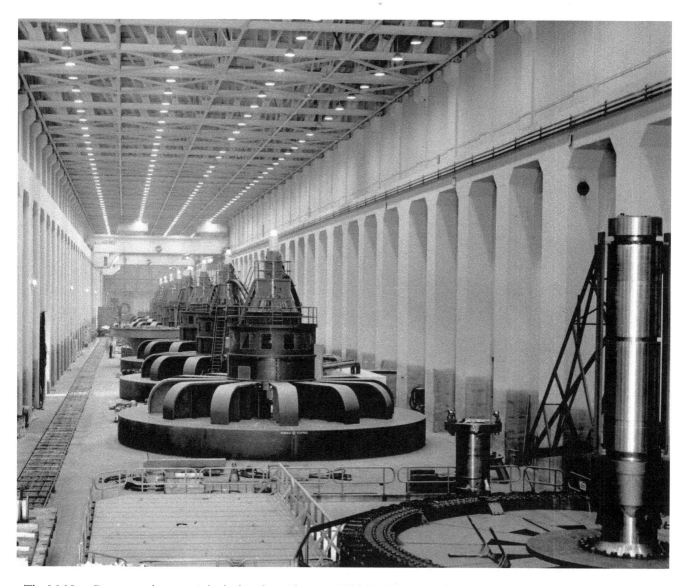

The McNary Dam powerhouse as it looked in the mid-1950s. With President Eisenhower on hand to speak to a crowd estimated at 30,000, McNary Dam was dedicated on September 23, 1954. The dam is named for Oregon senator Charles McNary and is located near Umatilla, Oregon, and Plymouth, Washington.

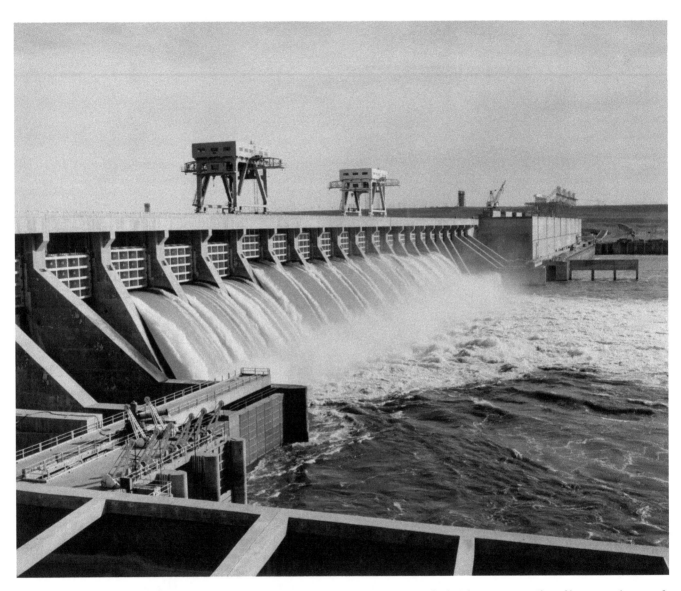

McNary Dam created a 64-mile-long reservoir (Lake Wallula) and has a navigation lock. There are 18 miles of levees, and most of the power generated is used to support Pasco, Kennewick, and Richland.

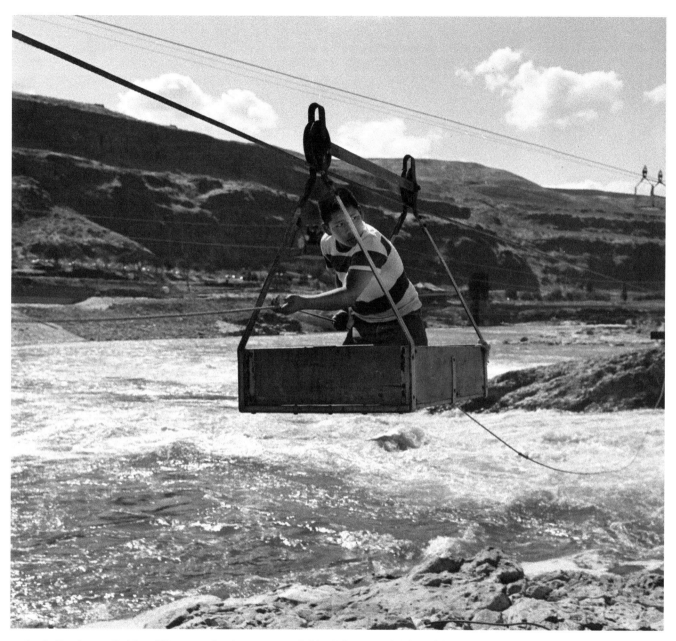

An Indian boy pulls himself in a wooden box car over Celilo Falls in 1954. The cable car was used to transport fishermen to and from the islands in the Columbia River. In 1957, the Dalles Dam completely inundated Celilo Falls, effectively ending centuries of fishing by the Umatilla, Yakama, Nez Perce, Warm Springs, Wasco, and Wishram tribes at this location on the Columbia.

Notes on the Photographs

These notes, listed by page number, attempt to include all aspects known of the photographs. Each of the photographs is identified by the page number, a title or description, photographer and collection, archive, and call or box number when applicable. Although every attempt was made to collect all data, in some cases complete data may have been unavailable due to the age and condition of some of the photographs and records.

70 NORTHERN PACIFIC
BRIDGE AT KALAMA
Washington State
Historical Society
2006.0.124

71 MILWAUKEE ROAD,
MALDEN
Washington State
Historical Society
1995.98.13

72 CONSTRUCTION OF
MONROE STREET BRIDGE
Library of Congress
pan 6a12740

73 LOGGERS TRAVEL TO
LOGGING CAMP ON
RAILCAR
Washington State
Historical Society
2007.48.83

74 TWO OPEN-AIR CARS
FILLED WITH TOURISTS
IN OLYMPIC NATIONAL
FOREST
Library of Congress
cph 3b41288

75 NORTHERN PACIFIC
TICKET OFFICE
Washington State
Historical Society
S1991.38.6

76 MILWAUKEE ROAD
OLYPIAN
Washington State
Historical Society
1943.42.28423

77 HOOD FROM 40 MILES
WEST
Washington State
Historical Society
1983.79.1.108

78 FISHERMAN AND CHILD
ON A FISHING VESSEL
Washington State
Historical Society
1943.42.27452

79 CREW OF THE MOTOR
CANNERY TENDER,
SUPERIOR
Washington State
Historical Society
1943.42.27493

80 APEX CANNERY SALMON
Washington State
Historical Society
1943.42.27678

81 APEX FISH COMPANY
INTERIOR
Washington State
Historical Society
1943.42.27682

82 LOGGERS ON SPEEDER
CAR NEAR YACOLT
Washington State
Historical Society
2007.48.159

83 GREATER NORTHERN
TYE DEPOT
Washington State
Historical Society
1943.42.27093

84 MAIN STREET,
WASHOUGAL
Washington State
Historical Society
2007.133.9

85 JULY 4TH EXCURSION
TO YACOLT
Washington State
Historical Society
2007.48.65

86 CUMBERLAND MINE
Washington State
Historical Society
1943.42.28229

87 HYDE AND COMPANY
CUMBERLAND MINES
Washington State
Historical Society
1943.42.28237

88 CAMP
Washington State
Historical Society
S1991.51.2.456

89 BUCKING TREES AT
YACOLT
Washington State
Historical Society
2007.48.98

90 THRESHING AT
ELLENSBURG
Washington State
Historical Society
1943.42.33109

91 HAULING WHEAT SACKS
Washington State
Historical Society
1943.42.33068

92 EVERYDAY IS SALMON
DAY
Washington State
Historical Society
2006.0.123

93 ICE FOR
REFRIGERATOR CARS
Washington State
Historical Society
1943.42.33141

94 COLUMBIA RIVER
Washington State
Historical Society
1943.42.33553

95 OLD STATE CAPITOL
Library of Congress
LC-USZ62-93704

96 GROUP CLIMBING
PARADISE GLACIER IN
MT. RAINIER
NATIONAL PARK
Library of Congress
cph 3c00874

97 CAMPING PARTY
COOKING AT CAMPFIRE
AND EATING NEAR TENT
IN INDIAN HENRY
Library of Congress
cph 3c 01035

98 BIRD'S-EYE VIEW OF
OLYMPIA, WASHINGTON
Library of Congress
cph 3b39880

99 SNOWPLOW
Washington State
Historical Society
1994.91.3.6

100 WHEAT HARVEST
Washington State
Historical Society
1994.0.333

101 MILITARY HORSEMANSHIP
SHOW
Library of Congress
pan 6a33974

102 PRESIDENT WOODROW
WILSON ADDRESSING
CROWD
Library of Congress
LC-USZ62-106648

103 OLYMPIC FLOUR TRUCK
Washington State
Historical Society
1957.64.B2547

104 THE DETROIT ELECTRIC
GOING FROM SEATTLE TO
MT. RAINIER
Library of Congress
cph 3b09919

105 MILWAUKEE ROAD NO.
16
Washington State
Historical Society
1943.42.39280

106 DONKEY ENGINE AT
WEST FORK LOGGING
COMPANY
Washington State
Historical Society
1957.64.B2725

108 FISHER FLOURING
MILL COMPANY
Washington State
Historical Society
1957.64.B2863

109 **NEWSREEL PHOTOGRAPHERS**
Washington State
Historical Society
1943.42.39297

110 **TEA SHIPMENT**
Washington State
Historical Society
1957.64.4467

111 **CURTIS ORCHARD IN GRANDVIEW**
Washington State
Historical Society
1943.42.42401

112 **BEN TURPIN**
Washington State
Historical Society
2004.69.87

113 **INSPECTING PILINGS IN COMMENCEMENT BAY**
Washington State
Historical Society
1943.42.46976

114 **MILDRED DAVIS, HAROLD LLOYD AND OTHERS**
Washington State
Historical Society
1957.64.B12367

115 **GREAT NORTHERN TRACK WORK**
Washington State
Library of Congress
2006.15.4

116 **MILWAUKEE ROAD**
Washington State
Historical Society
1943.42.48228

117 **WINDOW DISPLAY OF APPLES IN MAIN TICKET OFFICE**
Washington State
Historical Society
1943.42.48443169

118 **BABE RUTH**
Washington State
Historical Society
1943.42.50575

119 **CUSTOMS INSPECTORS INSPECT SILK**
Washington State
Historical Society
1943.42.48433

120 **UNLOADING EARTHENWARE AT GREAT NORTHERN DOCKS**
Washington State
Historical Society
1943.42.48489

121 **CASCADE TUNNEL CONSTRUCTION**
Washingotn State
Historical Society
2003.35.5

122 **SKAGIT INCLINE**
Washington State
Historical Society
2003.100.14

123 **NORTH COAST LIMITED**
Washington State
Historical Society
1943.42.49677

124 **CELILO FALLS**
Washington State
Historical Society
2005.0.143

126 **TACOMA NARROWS BRIDGE CONSTRUCTION**
Washington State
Historical Society
1985.50.90.2

127 **GALLOPING GERTIE**
Washington State
Historical Society
2007.0.77.51

128 **TACOMA NARROWS BRIDGE CONSTRUCTION**
Washington State
Historical Society
1991.59.1.22.3

129 **MCNARY DAM POWERHOUSE**
Washington State
Historical Society
2003.100.11

130 **MCNARY DAM**
Washington State
Historical Society
2003.100.9

131 **CELILO FALLS CABLE CAR**
Washington State
Historical Society
1974.35.2261.28

Printed in the USA
CPSIA information can be obtained
at www.ICGtesting.com
JSHW072022140824
68134JS00042B/3749

9 781683 369042